CW00553621

YOUGHAL

KIERAN GROEGER

The
History
Press
Ireland

First published 2016

The History Press Ireland
50 City Quay
Dublin 2
Ireland
www.thehistorypress.ie

The History Press Ireland is a member of Publishing Ireland, the Irish
book publishers' association.

British Library Cataloguing in Publication Data.
A catalogue record for this book is available from the British Library.

ISBN 978 1 84588 901 2

Typesetting and origination by The History Press

CONTENTS

ACKNOWLEDGEMENTS

They say it takes a community to raise a child and you could probably say the same about this publication. Literally the entire community seems to have been involved in this book: people arrived with bags of photographs, with hard disks, with envelopes; the local radio station (Community Radio Youghal) and newspapers (*East Cork Journal* and *Youghal News*) were really supportive and featured the quest for photographs; and emails with photographs arrived daily. It seemed as if this was a project whose time had come and people were delighted to help out.

A number of families in particular have collections of photographs – the Horgan, Burke, Brooke, Roche, Hackett and Donnelly families on their own could supply enough material to fill more than one book and offered their resources.

For further information on most of the chapters in this book the reader is advised to check Mike Hackett's extensive range of local history books. He has been unstinting and most generous with his help in the preparation of this book.

Michael Hussey and Kieran McCarthy have done tremendous work in archiving old photographic and video footage of the town, especially the work of Bob Bickerdike and Mikey Roche. Some of this is on YouTube. They were both very helpful.

Many people offered suggestions, photographs, postcards and stories, and others helped identify the photograph or the occasion. In particular, I would like to thank Gene Roche, Helen Keane, Kay and Tommy Donnelly, Mary and Declan O'Callaghan, Catherine Matthis, Catherine Canavan, Olly Casey, Liam Burke, Peter and Mary Carson, Christy Buttimer, Lesley and Evelyn Snell, Ken Brookes, Gordon and Beryl Good, Frank Keane, Bob Rock, Jim McCarthy, Kevin Power, John Heaphy, Frankie Mills, Tommy Bulman, Eddy Fizgerald, Walter Verling, Maurice and Geraldine Browne, Hilda Clarke, Frankie Mills, Linda Donoghue, Nell Murphy, Sean Lawlor, Ger Flanagan, Gerard Kenneally and Christy McCarthy, Tommy Delacour, Clifford Winser, David Kelly, and Aonghus O'Broin.

The *Irish Examiner* and *Evening Echo* offered support and the use of their images as did Waterford County Museum, Cork County Library, and the National Library of Ireland (NLI). To all of you – a sincere thanks.

To my wife, Brid, special thanks for all the helpful comments and support.

If an error or an omission has been made in attributing an image or in identification, please contact the author so that corrections or additions can be made if there are future editions. A genuine effort has been made to correctly identify and acknowledge all contributions. It was not easy!

Some of the photographs are from old glass plates, in delicate condition, some are cracked, and some are mouldy. When you realise that some of the photographs are over 100 years old, you make allowances for minor faults.

INTRODUCTION

There are really two Youghals. One is a place that was part of my childhood, the other I got to know and love as an adult. The Lighthouse Hill divides these two very different towns with the beach on one side, along with Perks Amusement Park, the railway station, the caravan parks, Claycastle, the army camps, Redbarn, and Ballyvergan bog. A lot of this has changed over the years, except for the sea and the beach, but the memory remains.

On the other side of the hill is the Green Park, the medieval walled town, the iconic Clock Gate, the strange meandering Main Street and a host of little laneways. As a child enjoying the beach and sea I rarely ventured into that other Youghal, except for the occasional trip to Cooper's Cafe, or a ferry across to Monatrea.

Our family migrated to Youghal for the summer months. At first we rented a house from Dr Kennedy on the Front Strand, but then my dad heard about railway carriages and we bought one! Ours was not like Nellie Maher's carriage – reputed to come from some royal train. Ours was the bog-standard basic, which cost a fiver to buy then but was worth so much more to us for our holidays. A few still remain on the outskirts. And that is where we spent our summer holidays. We seemed to have spent the entire summer on the beach, or occasionally, with our little bag of pennies, visiting Perks.

Driving to Youghal was an adventure. The bypass roads were not yet built. There was time to see and wonder. We got to remember certain towns and landmarks – the woman with the pram and the little doll, the house with the horse's head, long delays in traffic as cars filtered off to Garryvoe at Castlemartyr. When we got to the petrol station at Killeagh, you could nearly smell the sea; Youghal was just around the corner. And it never rained.

Each of us children had little jobs to do – mine was to get a pot of seawater each day to boil the Ballycotton new potatoes and the flavour was magic as the little balls of flour would burst out of their jackets and we ate them skin and all.

And then, as an adult, I came to live and work in Youghal and found a different world on the other side of the hill. In this book we will take a ramble along that journey, evoking memories here and there of one side of the hill and finding out about the other side, stopping now and then to see what is going on. Or maybe what *was* going on.

Youghal started to become a seaside resort during the Victorian era when ordinary people began to go on holiday. This was greatly assisted by the arrival of the railway. For generations of Cork people the trip to Youghal by train was the start of the summer holidays. And so we begin our journey down that memory lane, taking the train to Youghal.

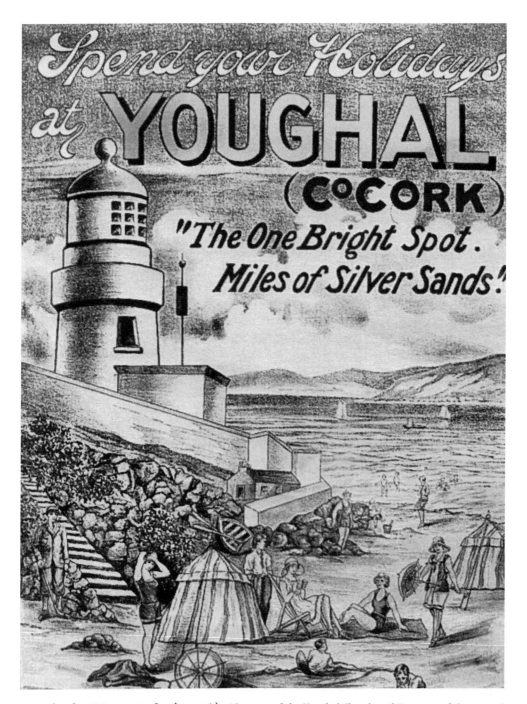

An early advertising poster for the seaside. (Courtesy of the Youghal Chamber of Tourism and Commerce)

1

A SEASIDE RESORT

THE FRONT STRAND

Front Strand starts with the railway station, a busy little area where hundreds of people arrived daily during the summer season. There was a buzz about the place when the train arrived, with crowds getting on or off. You might have seen Mikey Roche with his little pushcart bringing back reels of film and getting another set for the cinema. Or just watched as the steam engine was uncoupled and swung around on a big turning wheel to face back to Cork. In those days foreign travel was rare and Youghal was 'THE' holiday spot for a lot of people.

Trainloads of schoolchildren would be brought to Youghal for a day trip. It must have been hectic for teachers, trying to contain exuberant children. There are stories, probably just stories, of boys climbing onto the roof of carriages! And then there were the family day-trippers, coming to spend the day at Youghal and take the sea air. A lot of women went with their children while the men would stay in Cork and work. These were the women who would pay six pennies for a kettle of water to make the tea and have the picnic. And Nellie Maher was ready with the boiling water for them.

There was a sense of wonder as people got off the train and made their way to the beach and heard the Merrys, and saw the Showboat ballroom and the changing boxes for bathers. It was a whole new world for many. Many were not used to seeing the ocean up close and personal.

As they arrived the street sellers would be ready with the stalls groaning under the weight of the 'sweeties', fruit, chocolate bars, striped penny rocks, slabs of toffee which you cracked on your knee to show how brave you were, toffee apples, boiling water, and whatever might take your fancy.

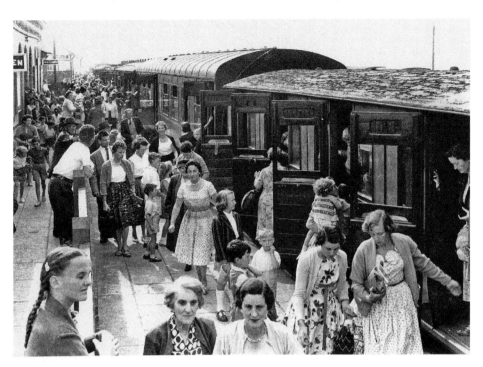

A family trip to Youghal. (Courtesy of the *Irish Examiner*)

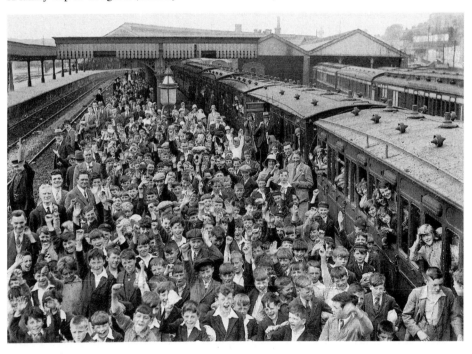

This picture of the school trip to Youghal was taken at the Glanmire Station in Cork but the destination is very obvious in the faces of the children who are evidently as high as kites and raring to go! (Courtesy of the *Irish Examiner*)

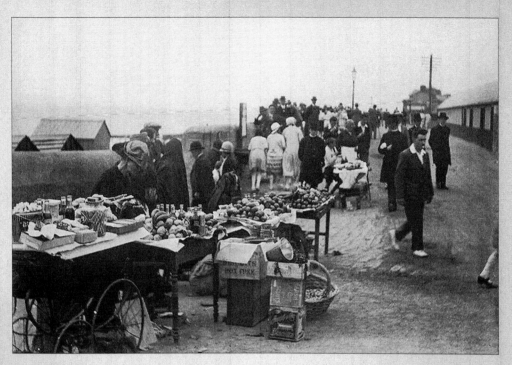

Hawkers at the Front Strand. (Courtesy of the Horgan family)

A touch of nerves on seeing the sea.
(Courtesy of the Mikey Roche collection)

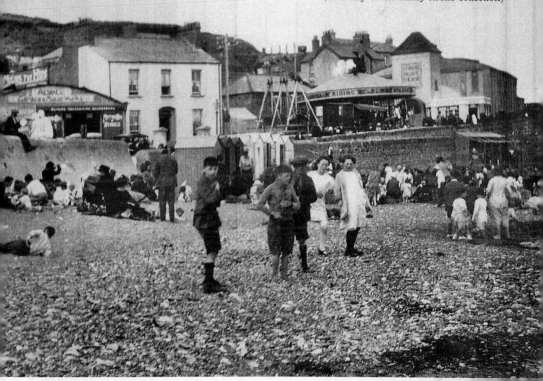

Crowds on the beach. (Courtesy of the NLI, Lawrence Collection)

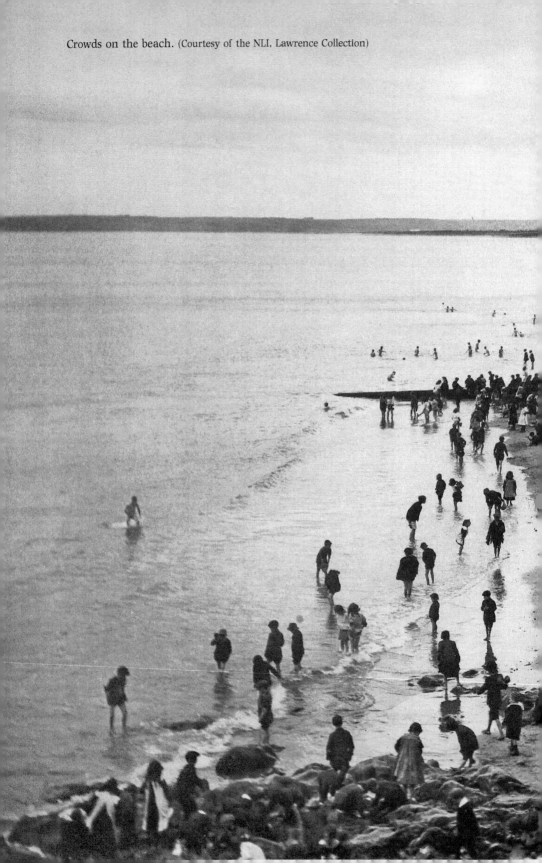

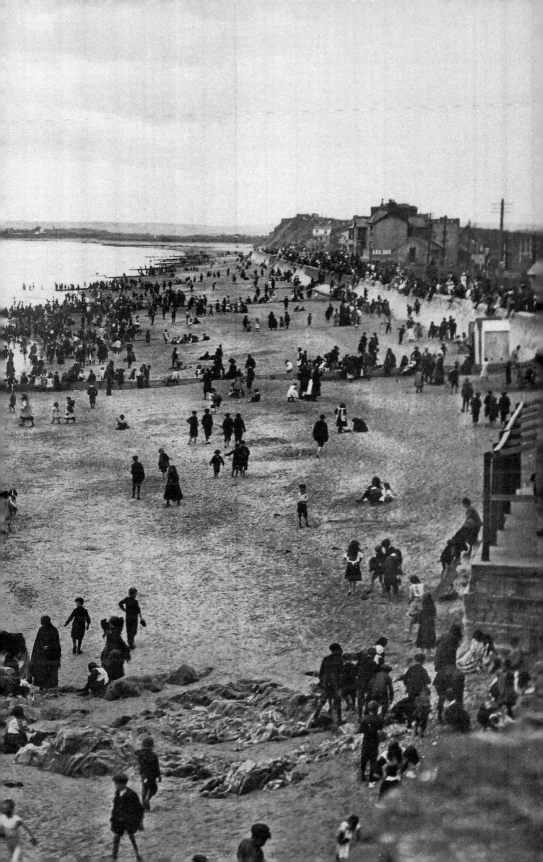

Images like this are wonderful to study. Here a woman with a headscarf kneels with a little box camera to capture the moment, a little girl struggles with her swimming costume, a brave little boy makes his way on the stone walkway, there are little dogs, a few prams, and one baby looking at the scene; maybe it is not too warm as there are cardigans being worn. All human life is there. (Courtesy of the *Irish Examiner*)

Roll up the trouser legs or tuck the dress into the knickers and paddle away!
(Courtesy of Frank Keane)

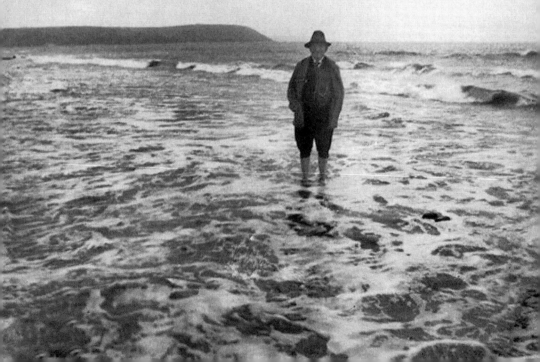

HEADING TOWARDS CLAYCASTLE

Walking the promenade over to Claycastle was a major part of the seaside experience. In the past the fairground was at the Claycastle end of the beach and then moved nearer the railway station.

There were shops there, little wooden shacks and stalls selling boiling water so that people could make a cup of tea. The most famous water seller was Nellie Maher who made more money in the summer selling water than the rest of the year as a librarian. She lived, for the summer, in a wonderful railway carriage, fit for a queen, they said, and it probably was; it was made specially for a royal train journey.

There were many little shops – Mr Attridge had one and Dolly Goulding another. She lived in her little shop all summer long. But times they were a-changing and the little shacks and stalls had to make way for progress.

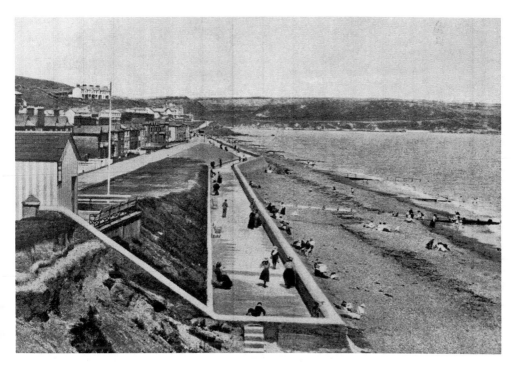

The Front Strand in elegant Edwardian times. (Courtesy of the O'Callaghan family)

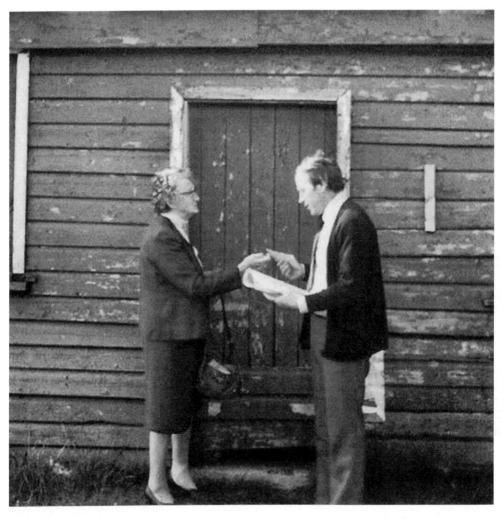

Dolly Goulding handing the keys to her shop to the Town Clerk, Larry Cunningham. (Courtesy of the Carson family)

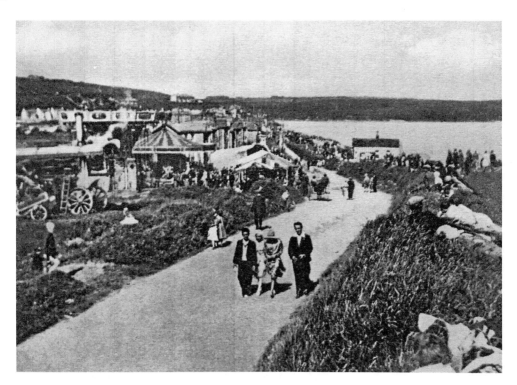

Heading over to Claycastle. (Courtesy of the Matthis family)

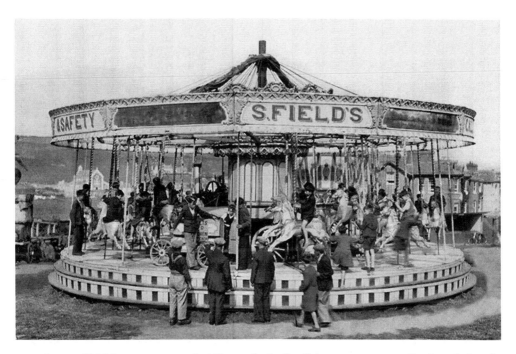

Sammy Fields' merry-go-round at Claycastle, in the distance you can see the Strand church.
(Courtesy of the Horgan family)

CLAYCASTLE

The army had been coming to Claycastle for a couple of hundred years. Each contingent of soldiers would come for a week or two of musketry practice. In the late nineteenth century the solders came by train and marched over to Claycastle, flags flying, pipers piping, drums beating and all the razzmatazz an army contingent can create.

There was a large mound of earth, in front of which would be targets for the soldiers to shoot at. Occasionally they missed and the bullets whizzed out to sea. A decent rifle could send a bullet a mile out to sea.

Being assured of some 200 to 300 young soldiers coming to town every week was wonderful for the local economy – not just the pubs and the dance halls, but tailors, bakers, grocers, shoemakers – everyone somehow or other felt the knock-on effect of the army presence and a few of the local girls the knocked-up effect, I don't doubt!

And on Sundays there was an open-air Mass at the camp, well attended by locals and day-trippers.

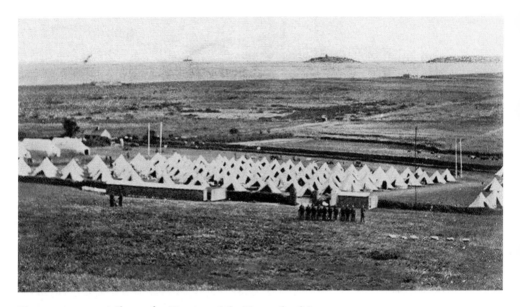

The army camp at Claycastle. (Courtesy of the Horgan family)

At this point we will turn around and head back towards the railway station but this time we continue on up the little hill towards the lighthouse, the Diving Rocks and then into town. On our right, the little street shops are still selling their goods. Ahead of us is the Showboat and maybe Mick Delahunty or Acker Bilk might be playing. Acker Bilk was no stranger to the Youghal shore.

Going to the Showboat was a real night out and some people travelled by train especially to get there. Mick Delahunty and his orchestra used the Showboat Express. We will get back to the Showboat later in the book to tell you about the night Mick Delahunty played, Noel Purcell sang and a goat appeared on the dance floor! And it wasn't the devil – that was another dance hall. This was a real, ordinary goat staying in the hotel across the road.

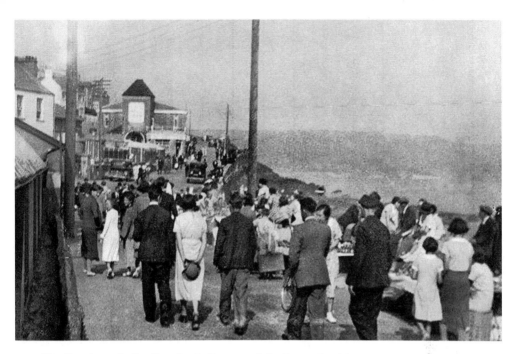

Heading towards the Showboat. (Courtesy of the Horgan family)

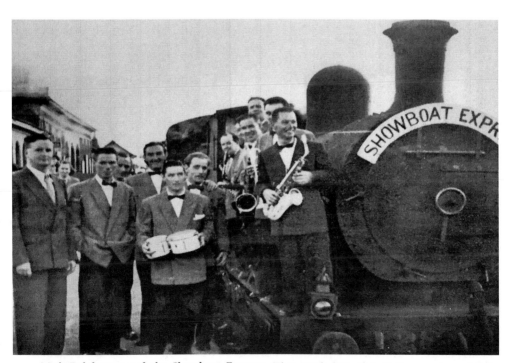

Mick Delahunty and the Showboat Express. (Photograph from Clancy's Bar, courtesy of Perks Amusement Arcade)

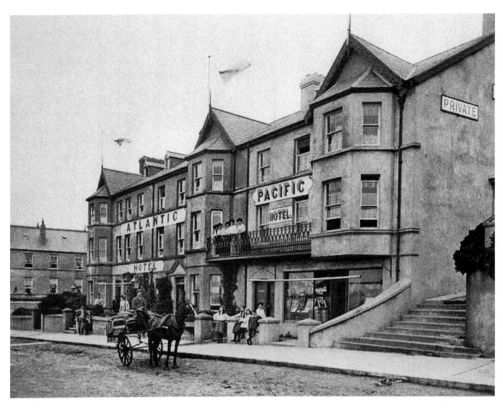

There were two hotels behind Clancy's Bar – the Atlantic and the Pacific. (Courtesy of the NLI, Poole Collection)

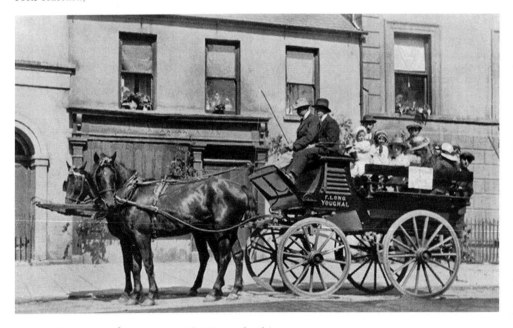

The two-horse taxicab. (Courtesy of the Horgan family)

THE DIVING ROCKS

There are forty-nine steps down to the Diving Rocks and at high tide it is a wonderful place for a swim. The little diving board is popular with the good swimmers.

The Diving Rocks were originally an all-male bathing place but women did make their way there eventually. Even though it was an all-male area there were still changing cubicles for the sake of modesty.

Seeing the ships in the bay on their way out or in must have evoked great excitement among those on the rocks. Frankie Mills, a local historian, recalls how when he was a young man, he asked one of the old salts how they managed to find their way to America without all the fancy equipment available today. 'Go south till the butter melts – then turn west and you get to America.'

Not all boats made it safely into Youghal and sometimes a boat would get lodged on the rocks at the entrance to the harbour. The *Queen of Gloucester* got stuck on the rocks in 1911. Rumour has it that the captain was put off the ship for being drunk and the ship sailed off without him. Someone shouted, 'There goes the queen!' The captain, somewhat in his cups, muttered, 'To hell with the queen', was overheard by a suspicious policeman and was arrested for sedition!

(Courtesy of the Horgan family)

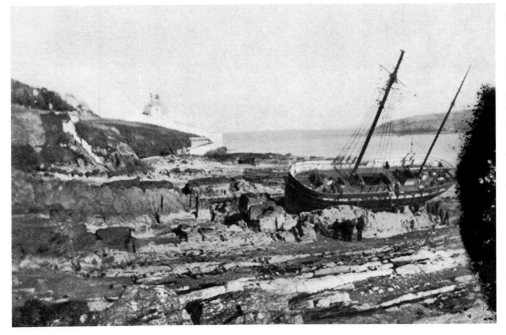

The *Queen of Gloucester* waiting for a high tide to float her off, while several locals are examining the hull from the safety of the rocks, 1911. (Courtesy of the Horgan family)

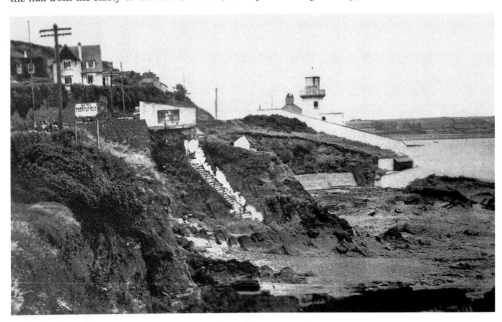

In this image of the lighthouse note the little shop at the top. It was owned by Tom Donovan or 'Pop' as he was called. He was an ex-army man who built the shop, against all advice, on the cliff edge. It was precariously balanced but managed to survive. It was a popular shop for children from the town going over to the beach. At the sea edge is a cabin with changing cubicles. (Courtesy of the Matthis family)

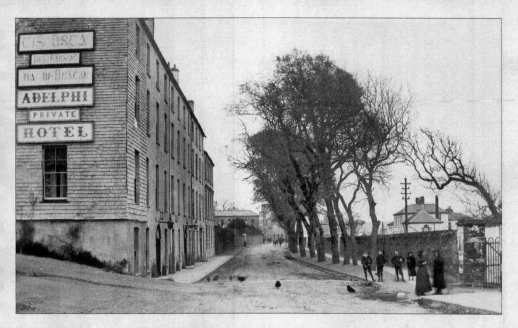

The Walter Raleigh Hotel (then the Adelphi). (Courtesy of the NLI, Lawrence Collection)

The Green Park where an army band is playing.
(Courtesy of the Horgan family)

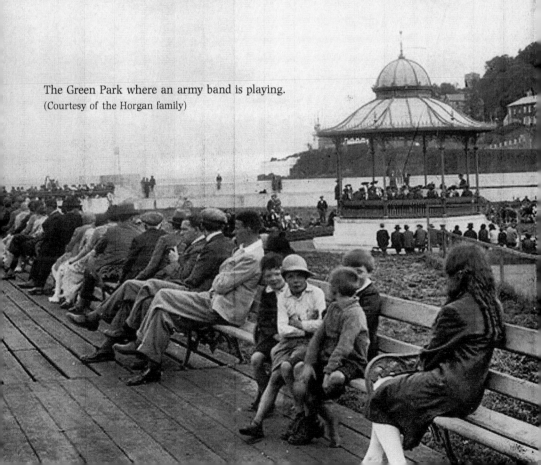

YOUGHAL URBAN DISTRICT COUNCIL

BAND RECITAL

By kind permission of COMDT. JOHN J. LEWIS, Officer
Commanding 19th Infantry Battalion,

A BAND RECITAL

WILL BE GIVEN ON

SUNDAY, JULY 13TH, '41

IN THE

GREEN PARK,

FROM 8 P.M. TO 10 P.M.

The following Programme will be rendered :—

1.	March	-	"Punjaub"	-	Payne
2.	Selection	-	"Irish Airs"	-	Hartmann
3.	Selection	-	"The Arcadians"	-	Arr. S. Douglas
4.	Selection	-	"The Bohemian Girl"	-	Balfe
5.	Selection	-	"In Coonland"	-	Bidgood
6.	Selection	-	"Walses from Vienna"	-	Strauss
7.	Selection	-	"Old and New"	-	Hermann Finck
8.	Selection	-	"Sweethearts of Yesterday"	-	Arr. Denis Wright
			"National Anthem."		

Conductor - - LIEUT. D. P. O'HARA.

ADMISSION FREE.

By Order, URBAN DISTRICT COUNCIL.

M. H. WALSH, Town Clerk.

Office—Town Hall, Youghal, 10th July, 1941.

FIELD. PRINTER, YOUGHAL

A band recital at the Green Park. (Courtesy of Frank Keane)

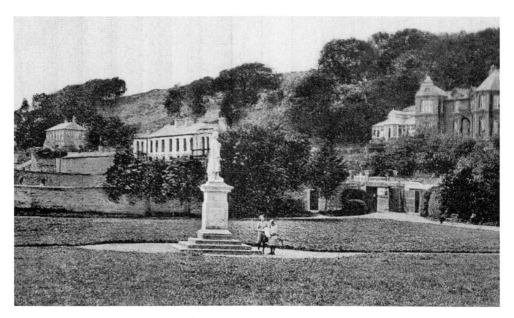

View of Marymount from the Green Park. (Courtesy of Bob Rock)

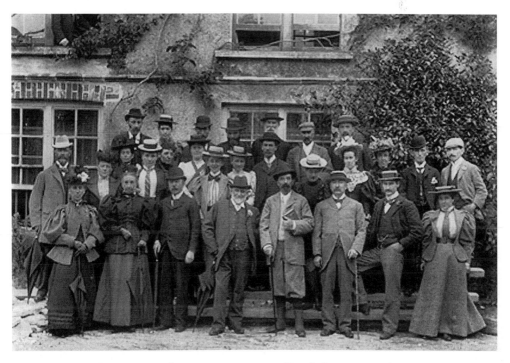

A group of historians and antiquarians visiting Youghal. Historians began to take note of Youghal during the nineteenth century when archaeology and antiquarian interests began in earnest. Youghal had much to offer them – the town walls have survived, one Watergate into the town has survived, as has St Mary's Collegiate church, the medieval streetscape, and the ruins of so many old buildings. (Courtesy of the NLI, Poole Collection)

As we leave the beach area of Youghal, we cast a final look back at the past, where Olly and Ann Casey are courting, walking the prom as young lovers do. She has the little transistor radio because, they say, Larry Gogan is coming to Pasley's Shop and Ann wants to keep in touch with the news – we will drop in to Pasley's later. (Courtesy of Olly Casey)

The image of the pigs seems a little bewildering, although there are ample stories of the havoc caused by marauding swine in *The Annals of Youghal*. They may have been bought at the fair earlier and are being driven towards their new home, in a somewhat leisurely fashion. The building on the left is the Devonshire Arms Hotel, built by the Duke of Devonshire way back in the early eighteenth century. (Courtesy of the NLI, Lawrence Collection)

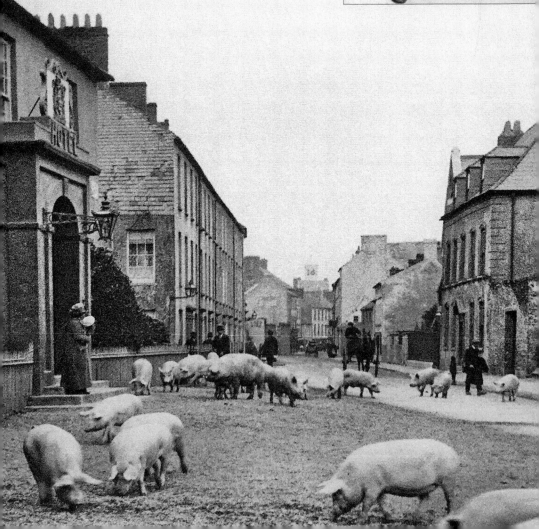

2

STREETSCAPES

There are many maps of Youghal. The most famous is the Pacata Hibernia map, which dates from around 1633, and the basic shape of the town has not changed very much since then.

Like many towns the main street is divided into two sections: the North Main Street and the South Main Street. The site of the post office today was the centre of town. On the Pacata Hibernia map there is a little crucifix there. This is where the town crier would do his 'Oyez! Oyez!' He would read the news and issue warnings. Here too, young criminals could be caged and recalcitrant women might be cucked, or scolds bridled. It was here too that the market would take place.

The little lane north of the cross is still called North Cross Lane. South Cross Lane is but a memory. The street is a strange shape, many houses and shops jutting out at odd angles. The stepping of the houses allowed people to look out to sea, or look at the Clock Gate. Many of the houses also have little gable windows, a surviving medieval feature.

There were two land gates into town and two water gates. The two land gates were the Clock Gate and the North Gate. The Clock Gate was an important point of entry to Youghal. From here rebel heads would stare from spikes, or pirates rot in chains. One water gate is gone but one remains and is usually called Cromwell's Arch as it was from here that he sailed back to England, having spent the winter in Youghal.

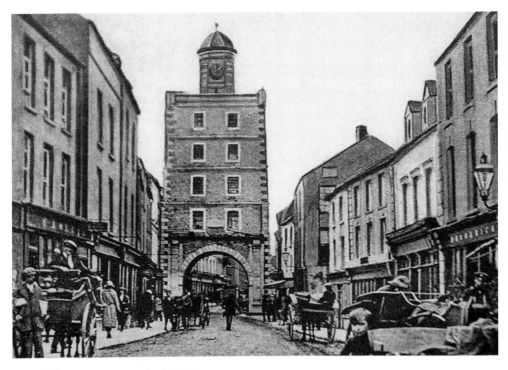

The Clock Gate. (Courtesy of Bob Rock)

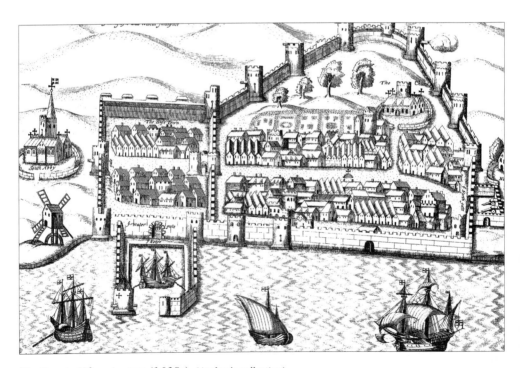

The Pacata Hibernia map (1630s). (Author's collection)

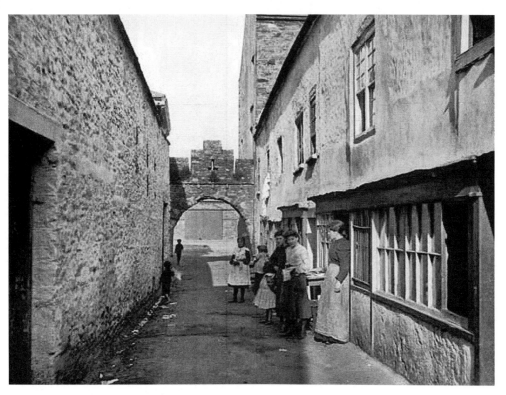

The Watergate, also called Cromwell's Arch. (Courtesy of the NLI, Lawrence Collection)

Main Street, Youghal – notice the houses jutting in front of each other. (Courtesy of the Horgan family)

The Priory in the early days of the town, it belonged to the Benedictines who had a hospice here. Traces of the graveyard are to the rear. This was the building that Oliver Cromwell chose as his residence when he spent the winter of 1648 here before leaving Youghal, by sea. The Priory has had a chequered history as a shop, a café, and a restaurant, which helped to preserve the building. Thankfully it has retained its front reasonably intact. (Courtesy of the Horgan family)

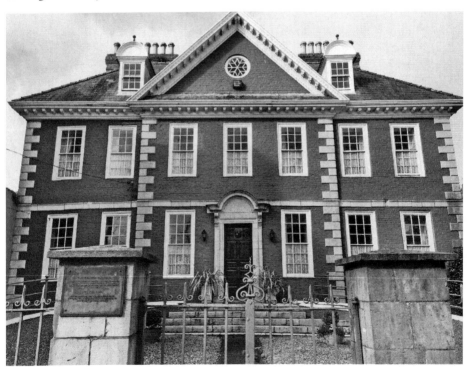

The Red House, built around 1705 by a Dutch architect. (Author's collection)

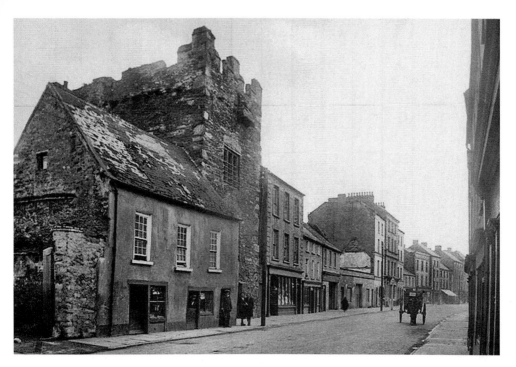

This is Tynte's Castle, home of Sir Edward Tynte. It was built as a medieval tower house and is now being restored. (Courtesy of the Horgan family)

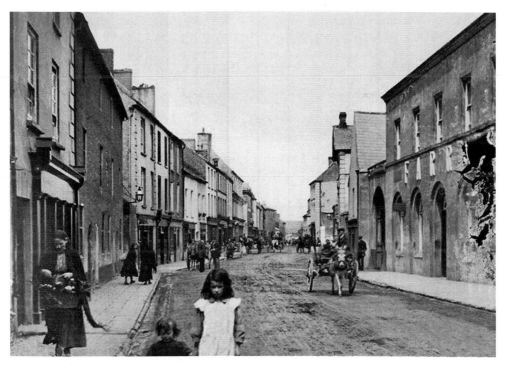

A view of the end of North Main Street. (Courtesy of the Horgan family)

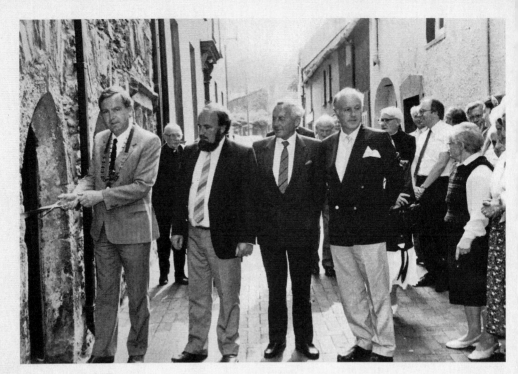

John Brosnan TD cutting the ribbon to mark the restoration of the houses. (Courtesy of Mike Hackett)

The alms houses date from the early seventeenth century when
Richard Boyle paid for six houses as homes for old soldiers.
(Courtesy of Mike Hackett)

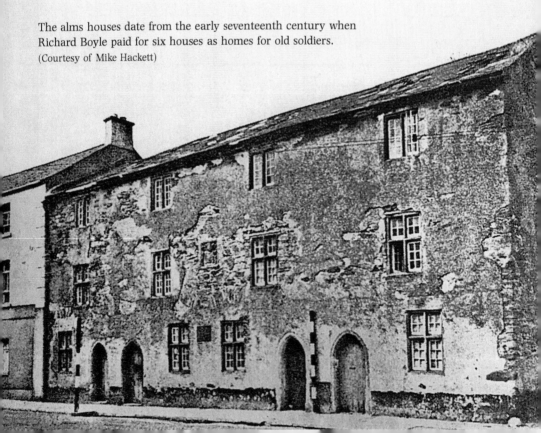

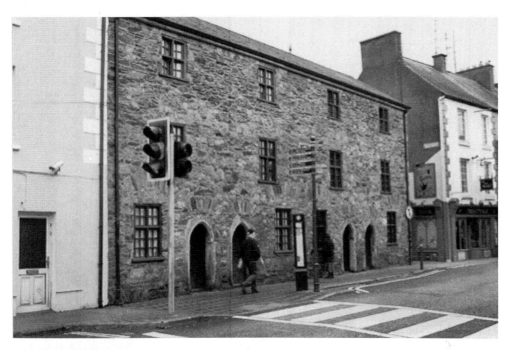

The alms houses in recent
years, now fully restored.
(Author's collection)

Probably one of the most
unique lanes in any town
in Ireland has to be Church
Lane. It leads from the alms
houses to St Mary's Collegiate
church. In architectural terms
it has examples of buildings
from the thirteenth to the
twentieth century all in the
one street. Now that has to be
fairly unique by any standard!
(Author's collection)

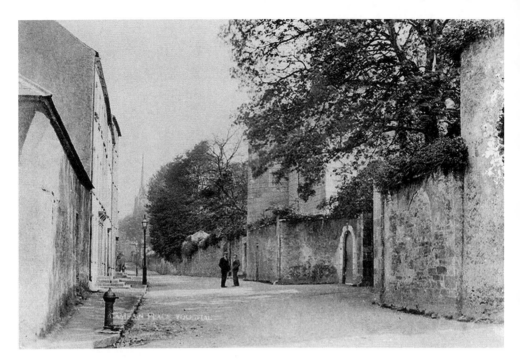

Emmet Place is at the top of Church Lane. The spire of the church in the distance was removed in 1925 so the photograph has to date from before that time. (Courtesy of the Horgan family)

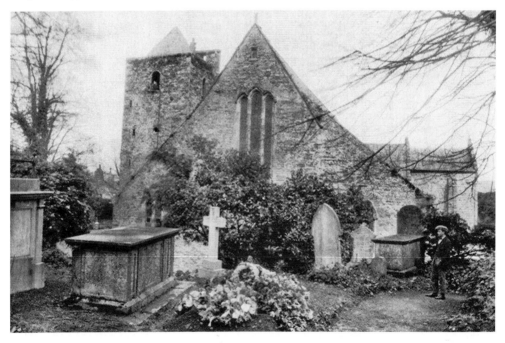

St Mary's Collegiate church dates from the early thirteenth century and has been in continuous use ever since. It has its original timber roof. (Courtesy of the Horgan family)

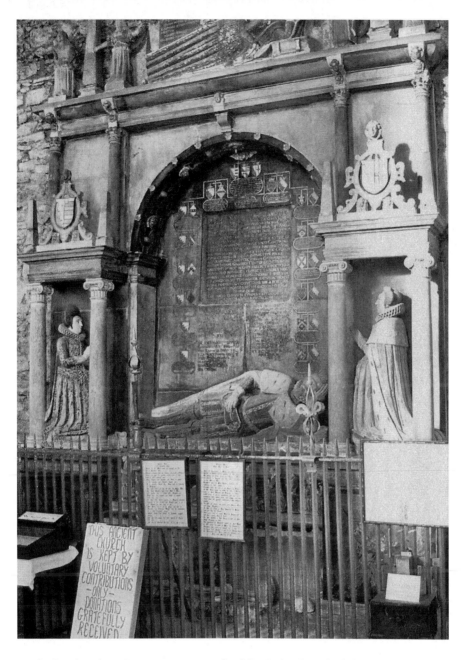

Inside the church is the ostentatious tomb of Sir Richard Boyle, first Earl of Cork. The figures on either side of his effigy are his two wives. (Author's collection)

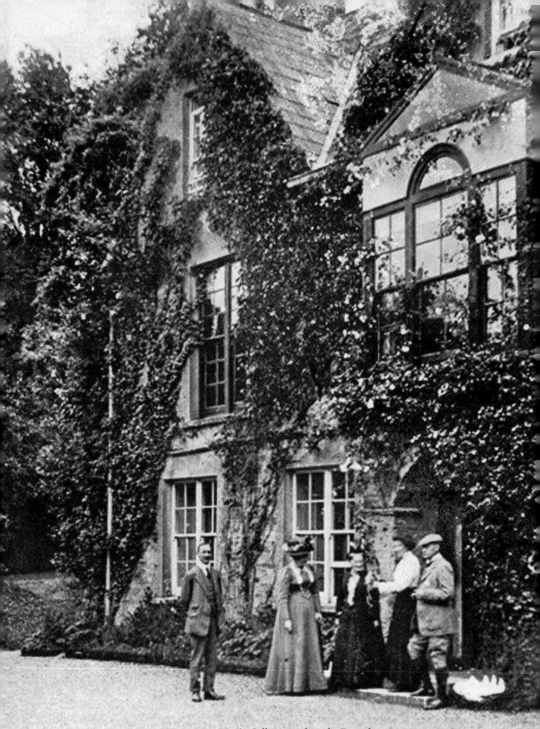

This is Myrtle Grove, next door to St Mary's Collegiate church. For a long time it was reputed to be the home of Sir Walter Raleigh. Today it urgently requires loving and extensive restoration. The photograph shows Sir Henry and Lady Blake and guests in the front garden. (Courtesy of the NLI, Lawrence Collection)

One of the bizarre incidents in the life of Myrtle Grove occurred in 1924, when the Chinese Government sent a delegation to demand the return of the golden gates to Kam Tin. In 1899 the residents of Kam Tin, a town in China, rebelled against the British Government. The British Army blew holes in the walls of the town and removed the golden gates, which they presented to the Governor of Hong Kong, Sir Henry Blake, who installed them in his garden at Myrtle Grove. Lady Blake allowed the Chinese to take back the gates and, as a gesture of gratitude, the Chinese delegation presented her with a replica set of gates. (Courtesy of the Horgan family)

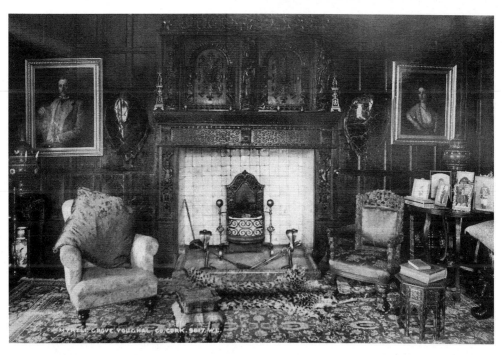

The interior of Myrtle Grove as it was in the early part of the twentieth century. Many well-known families lived here over the centuries. Sir John Pope Hennessy lived here for a while. He wrote a fine book about Sir Walter Raleigh's time in Ireland. (Courtesy of the NLI, Lawrence Collection)

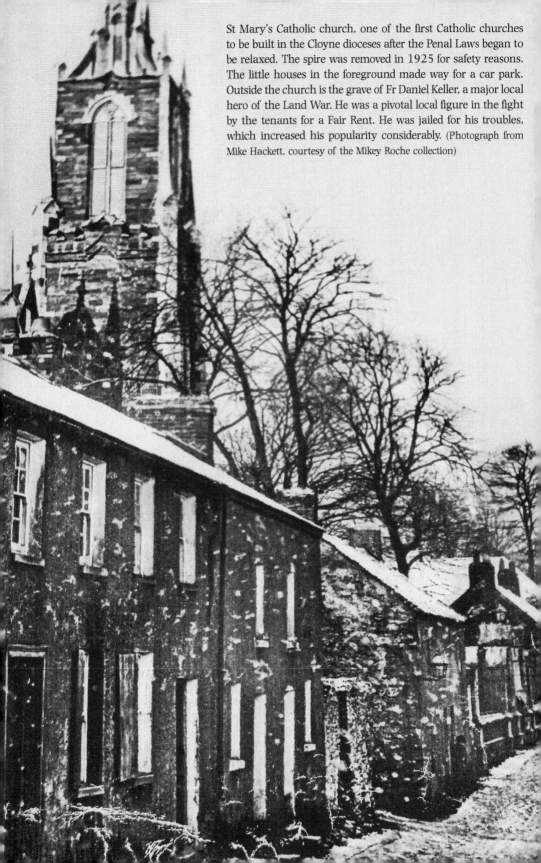

St Mary's Catholic church, one of the first Catholic churches to be built in the Cloyne dioceses after the Penal Laws began to be relaxed. The spire was removed in 1925 for safety reasons. The little houses in the foreground made way for a car park. Outside the church is the grave of Fr Daniel Keller, a major local hero of the Land War. He was a pivotal local figure in the fight by the tenants for a Fair Rent. He was jailed for his troubles, which increased his popularity considerably. (Photograph from Mike Hackett, courtesy of the Mikey Roche collection)

Gillett's Hill is almost a continuation of Chapel Lane. Gillett was a French Huguenot who came to Ireland to avoid religious persecution. The Huguenots fitted in to Youghal life very easily and soon became prominent business, civic and trades' men in the town. (Courtesy of Mikey Roche)

Behind Gillett's Hill and St Mary's are the town walls, sections of which you can walk on. They date from the thirteenth century and are the longest stretch of town walls in the Republic of Ireland. (Author's collection)

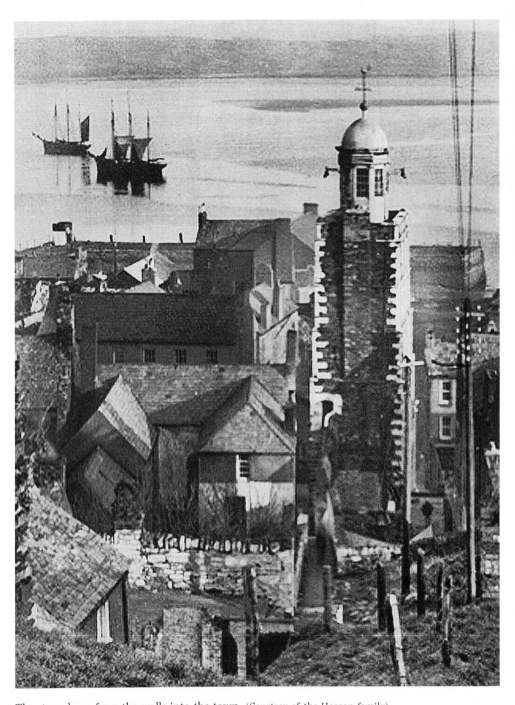

The steps down from the walls into the town. (Courtesy of the Horgan family)

3

THE BLACKWATER, THE BRIDGE AND THE SEA

OLD YOUGHAL BRIDGE

Old Youghal Bridge was a most peculiar bridge. Somewhere in the mists of time the belief developed that the bridge could not support heavy weights like lorries, buses or a lot of cars. Buses stopped at the Cork side, passengers walked across the bridge and hoped the Waterford bus would be waiting on the other side. Lorries were unloaded and men carried bags and goods across to waiting lorries on the other side. Cars went slowly across, the drivers fearful.

There were large barrels or bollards on the bridge, forcing cars to slow down and zigzag their way across. It was a one-way traffic system with long delays. It was tedious.

The bridge was a swing bridge, allowing one section to open and enable boats and ships to go upriver. Big sailing ships went upriver laden with goods (mostly coal) and came downriver with other goods like pit props, cider, leather, and grain. When the bridge was open there would, of course, be further delays.

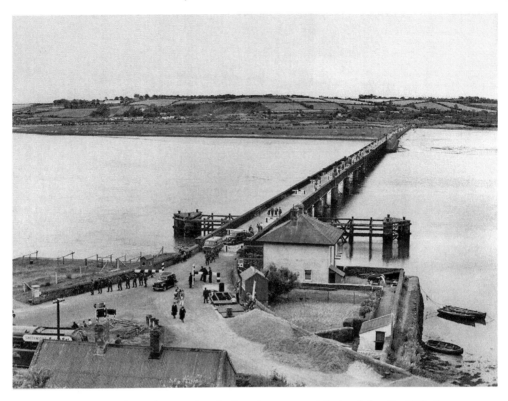

Old Youghal Bridge. The swing section is the piece nearest to land, by the little house.
(Courtesy of Tom Tobin)

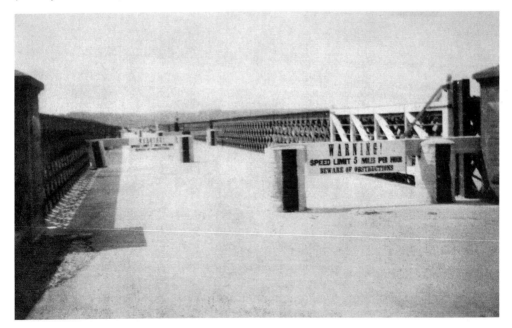

Zigzagging across Youghal Bridge. (Courtesy of Mike Hackett)

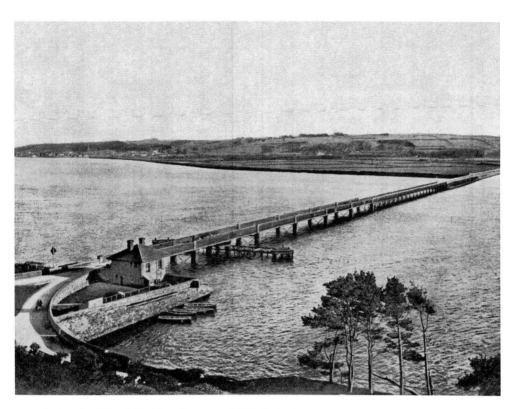

Postcard of the old bridge. (Courtesy of Willy Fraher)

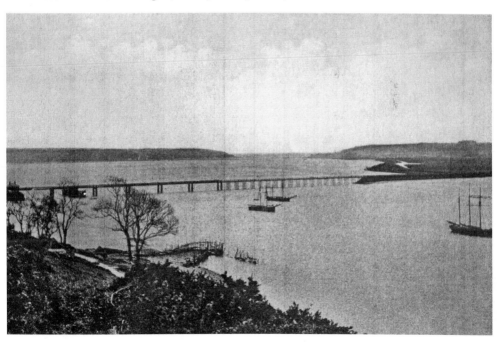

Postcard of the old bridge and ships moving upriver. (Courtesy of Bob Rock)

YOUGHAL QUAYSIDE

The quays in Youghal were busy places in the olden days. Many of the quays were named after the merchant families who used them – Harvey's Dock, Grubb's Quay, Allen's Quay. There was also Steamer's Quay. Probably the most central quay was the Pier Head, where the ferryboat crossed backwards and forwards between Youghal and the Ferrypoint, bringing people, goods, livestock.

This list of ferry tolls gives you an idea of what was carried back and forth. (Poster from Frank Keane, courtesy of Fields)

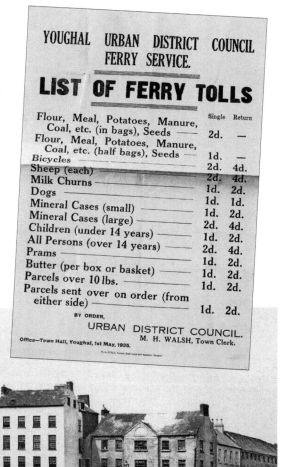

YOUGHAL URBAN DISTRICT COUNCIL FERRY SERVICE.

LIST OF FERRY TOLLS

	Single	Return
Flour, Meal, Potatoes, Manure, Coal, etc. (in bags), Seeds	2d.	—
Flour, Meal, Potatoes, Manure, Coal, etc. (half bags), Seeds	1d.	—
Bicycles	2d.	4d.
Sheep (each)	2d.	4d.
Milk Churns	1d.	2d.
Dogs	1d.	1d.
Mineral Cases (small)	1d.	2d.
Mineral Cases (large)	2d.	4d.
Children (under 14 years)	1d.	2d.
All Persons (over 14 years)	2d.	4d.
Prams	1d.	2d.
Butter (per box or basket)	1d.	2d.
Parcels over 10 lbs.	1d.	2d.
Parcels sent over on order (from either side)	1d.	2d.

BY ORDER,

URBAN DISTRICT COUNCIL.

M. H. WALSH, Town Clerk.

Office—Town Hall, Youghal, 1st May, 1935.

The Pier Head, near the present tourist office was the main hub of activity for passengers. This photograph is from the very early 1900s. People would wait by the white building or by the pier head, to take the ferry across to Monatrea. A bell would ring – it was on the little noticeboard by the quayside – inviting passengers to come aboard. (Courtesy of the NLI, Lawrence Collection)

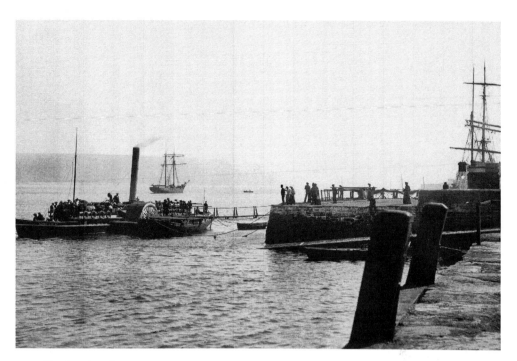

The Pier Head. (Courtesy of the NLI, Lawrence Collection)

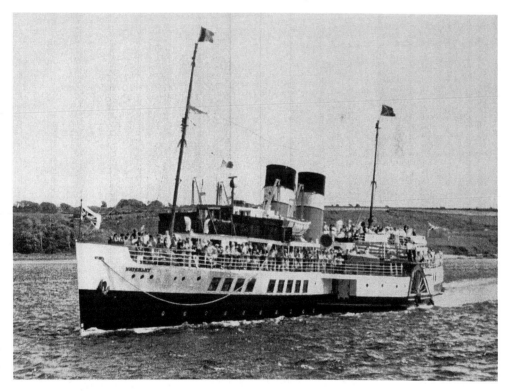

The paddle-steamer *Waverley* passing the Pier Head in the 1960s. (Courtesy of Tommy Bulman)

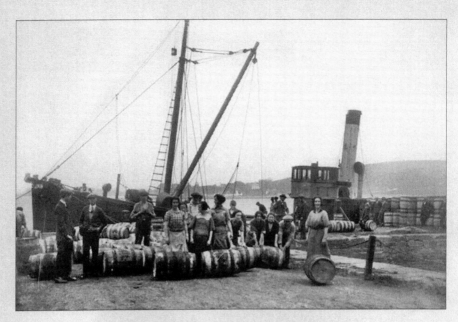

Unloading barrels at the Pier Head. (Courtesy of the Horgan family)

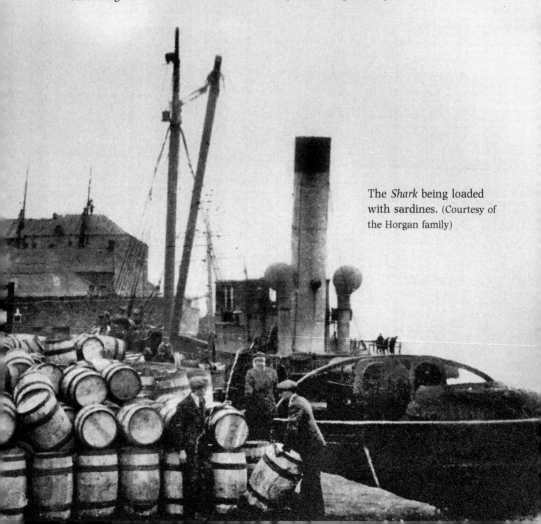

The *Shark* being loaded
with sardines. (Courtesy of
the Horgan family)

Loading the ships with pit props.
(Courtesy of the Horgan family)

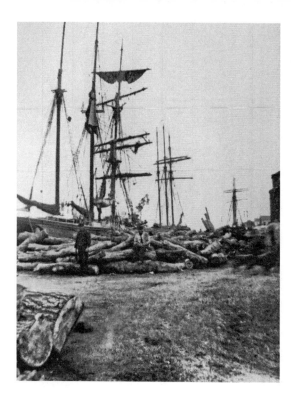

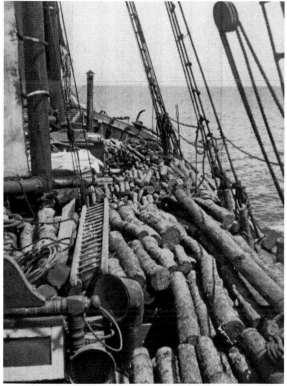

Here is the *Kathleen and May* heading off to Wales, fully laden. It looks very precarious. She would carry over 300 tons of coal to Ireland and try to carry as much timber back as possible. Coal was heavier and went easily into the hold. The pit props were all over the place! The *Nellie Fleming*, her sister ship, was overwhelmed by waves outside Waterford and sank with all aboard. Conditions were tough on board these ships, with one barrel of salted meat per journey (no variety in diet) and very rudimentary living conditions. (Courtesy of Frankie Mills)

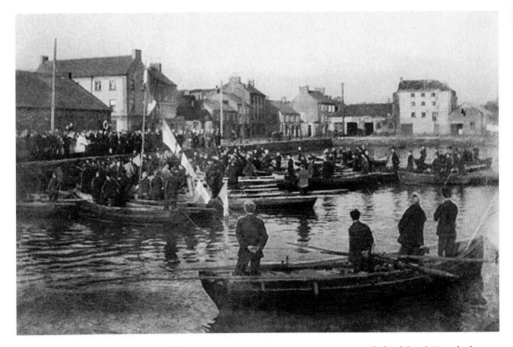

The blessing of the boats. Small fishing boats were an important part of the life of Youghal and the men and their families would gather annually at the Pier Head to have the boats blessed. (Courtesy of the Horgan family)

The Duke of Devonshire owned the fishing rights around Youghal and boats had to get permits to indicate whether they could fish on the upper or the lower stretch of the river or out in the bay. Boats would then put an 'L', a 'U' or an 'O' followed by a number to indicate their licence from the duke. Once a year the fishermen would report to the Devonshire Arms (owned by the duke) to pay for the licence to fish in the river.

Fish could be plentiful in those days before quotas and factory fishing boats. Once caught, the fish would then be packed in ice and sent off for sale in Cork or even further afield. Along the river from Youghal to Lismore there were icehouses, which were able to store ice for months for the fishermen long, long before electricity. Many of the icehouses are still there, including one in Youghal.

Sometimes, the mackerel were so plentiful that little boys would wade into the water and scoop them out. I've done it myself!

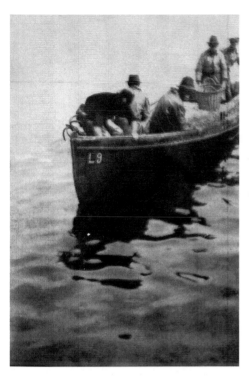

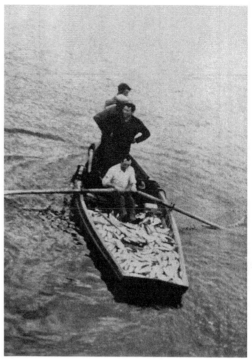

The *L9* was one of the fishing boats which had permission to fish on the river. This picture includes Noel Donoghue, Paddy Mahony, Bunny Buttimer and Christy Buttimer. This boat's permit is 'L9' – indicating it could fish the lower river.
(Courtesy of the Buttimer family)

A good catch!
(Courtesy of the Buttimer family)

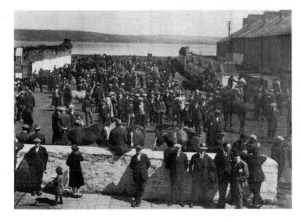

The annual horse fair was an important occasion in the town, and not just horses were sold. Pigs, chickens, sheep – all kinds of farm animals were sold. There were also hiring fairs and markets held.
(Courtesy of the Horgan family)

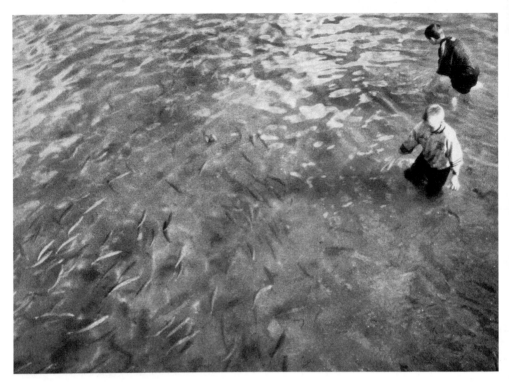

Little boys scooping mackerel. (Courtesy of Tommy Bulman)

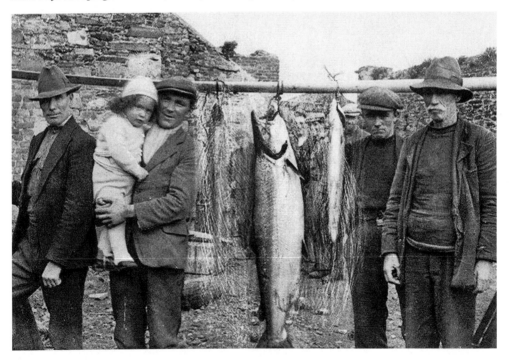

Some of the fish caught were enormous. (Courtesy of the Horgan family)

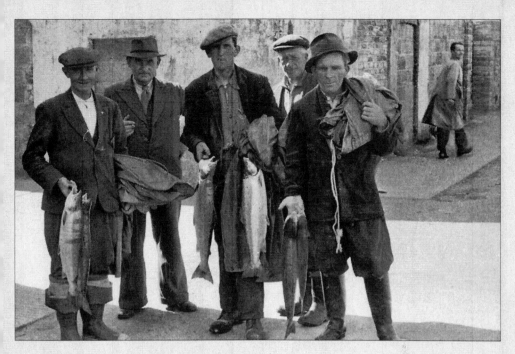

A variety of fish for sale. (Courtesy of the Horgan family)

A group of fishermen at Steamer's Quay.
(Courtesy of the Horgan family)

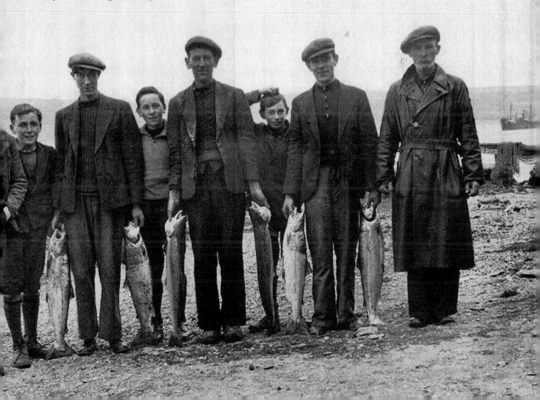

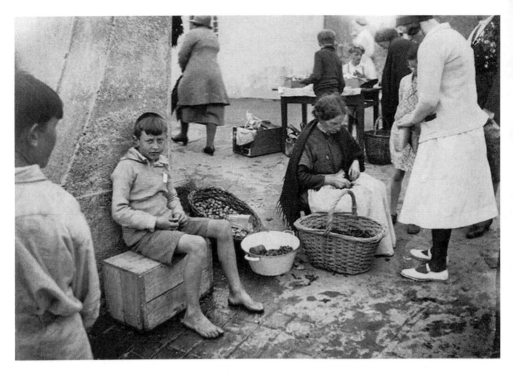

A young boy and his mother selling shellfish. (Courtesy of the Horgan family)

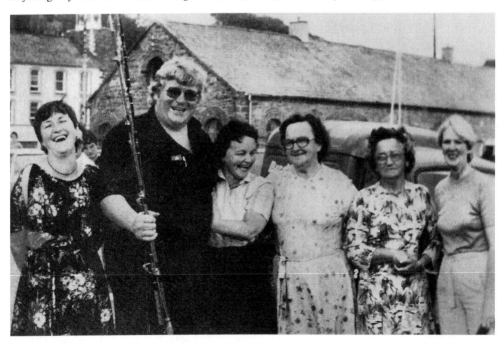

Hoping for another large catch was well-known fishing enthusiast and television personality Derek Davis, pictured here with some local ladies (Mary Bennett, Margaret Buttimer, Nora Buttimer, Lizzie Twomey and Mary Clancy). (Courtesy of the Buttimer family)

4

YOUGHAL
AT WORK

Ports have many little industries depending on them – like rope and sail making, making or mending nets, boat building, coopering, providing ice for the fish caught, filling the barrels with fish and ice, getting provisions for the ships.

The river provided an ample supply of raw material to make the bricks and bricks have been made on its slob banks long before the town was created. The reddish mud made a dense brick and beautiful pottery. Tony Breslin has written a fine book, *The Claymen of Youghal*, about pottery and brick making in the area.

The textile industry was probably the biggest single employer in the recent past, employing over 1,000 people at one point, with much of the workforce brought in on buses from Cork City, Tipperary and Waterford. The business was spread across the town with places to design, to dye wool, to weave, to store the finished product, and to display and sell the carpets.

For a number of years Youghal had full employment but then people found that carpets could be made cheaper abroad and the demand began to decline. Eventually the industry closed.

A succession of other industries came and went. After Youghal Carpets came Power Products, then Kodak and many, many more.

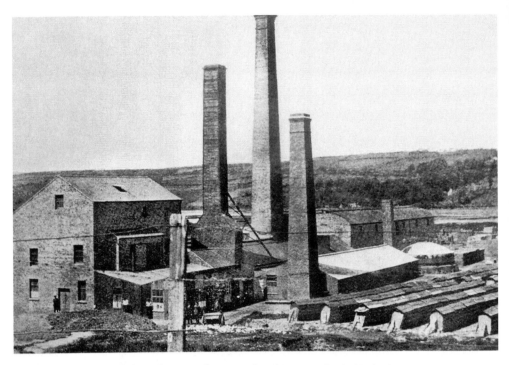

The brickworks provided employment for centuries. (Courtesy of Mike Hackett)

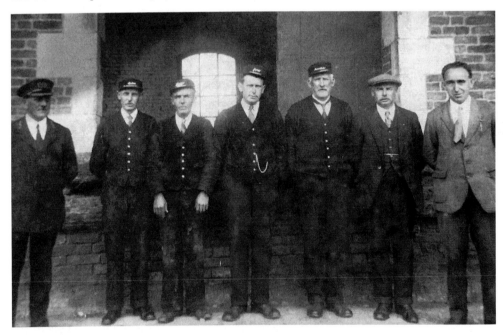

The railway station in Youghal. The stationmaster was John Browne, pictured here with his staff. From left to right: J. Browne, P. Sullivan Snr, P. McCarthy, P. Hill, M. Browne. The gentleman on the far right is unnamed but was a clerk from Cork City. (Courtesy of the Browne family)

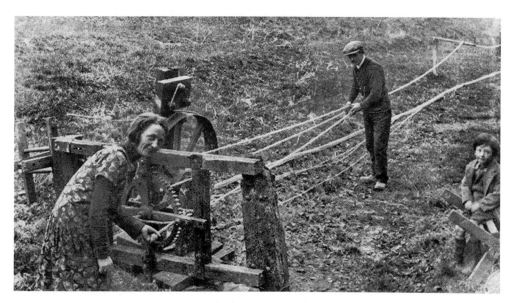

The O'Sullivan family making rope by the town walls. (Courtesy of the Horgan family)

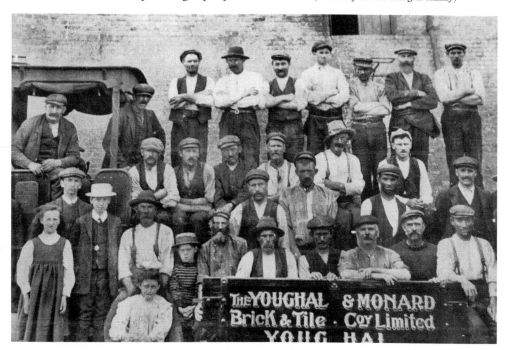

This is the Youghal and Monard Brick and Tile Company staff in 1912, welcoming the arrival of a steam wagon to bring bricks to the railway station. It was to be an effective and efficient means of transporting bricks to the railway station. The engine came with three trucks – one was to be loading at the brickworks while the second was en route to the station. When it arrived at the station it would be uncoupled ready for unloading and the third, newly unloaded, truck would be waiting at the station to return to the brickworks. The only time lost was the coupling or uncoupling of the trucks. (Courtesy of Mike Hackett)

Watsons made stained-glass windows in Youghal for several generations. Sadly the family no longer makes glass but their legacy does still lives on. Even the drawings and paintings of proposed projects are beautiful. Pictured here is the preliminary painting of a proposed glass panel. (Author's collection)

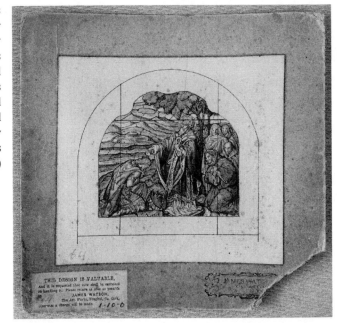

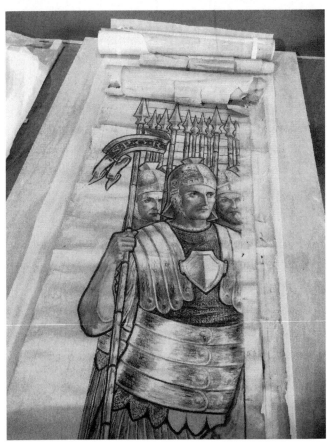

A Watson cartoon.
(Author's collection)

A Watson stained-glass window in Youghal.
(Author's collection)

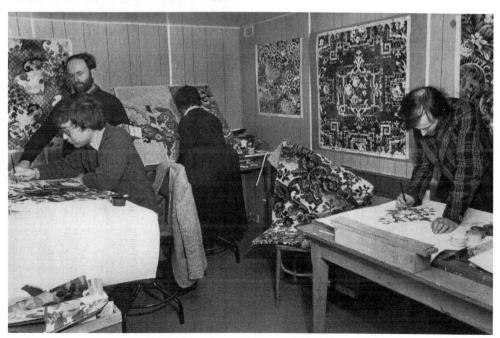

The Design Room at Youghal Carpets. (Courtesy of Tom Donnelly)

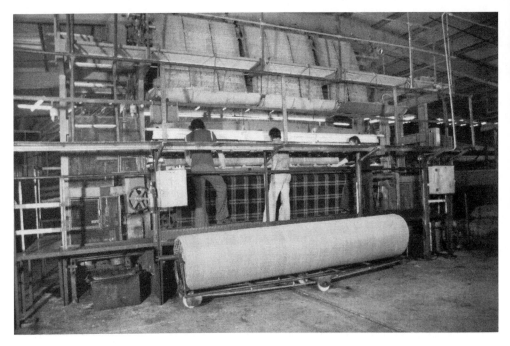

Then the design would move to the massive carpet-making looms and thousands and thousands of feet of high-quality carpet would be woven. (Courtesy of Tom Donnelly)

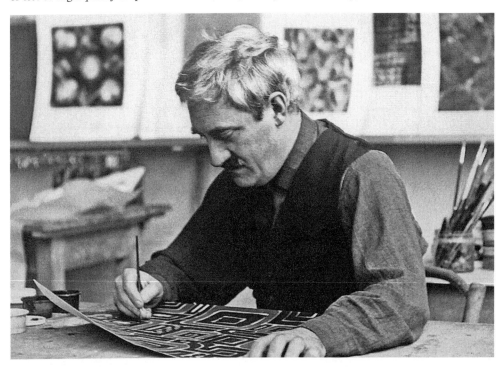

Brilliant abstract impressionist painters like Cormac Mehegan (pictured) were employed by Youghal Carpets to create stunning designs. (Courtesy of Tom Donnelly)

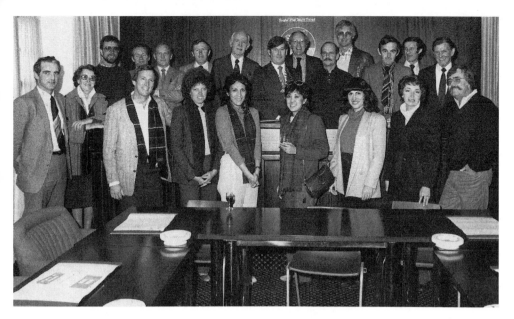

Visiting salespersons were given a civic reception at Youghal Carpets. (Unknown photographer, picture courtesy of Michael Hussey)

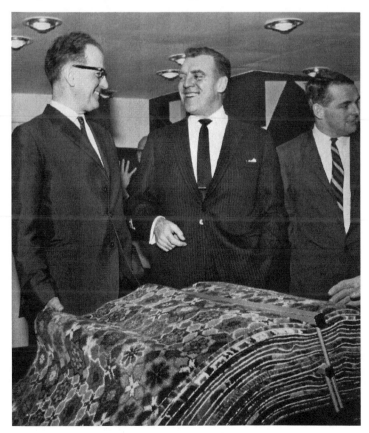

Television star Eamonn Andrews and rugby star Tommy Kiernan being shown around Youghal Carpets by the company's founder, John Murray.
(Courtesy of Tom Donnelly)

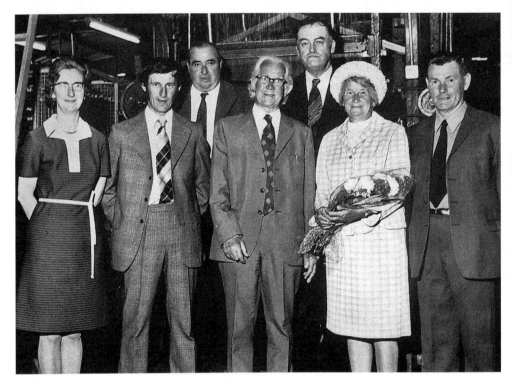

The retirement of Geoff Toft. Pictured here are Mary Russell, Tom Donnelly, Teddy McCarthy, Geoff Toft and his wife, between them is Mikey Whyte and John Lane on the far right. (Courtesy of Tom Donnelly)

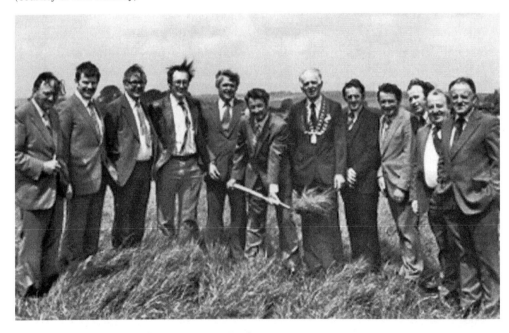

Cutting the sod for a new factory – Power Products. (Courtesy of Mike Hackett)

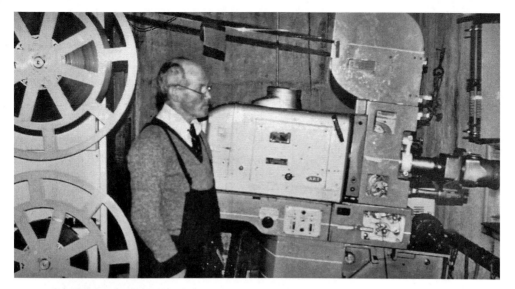

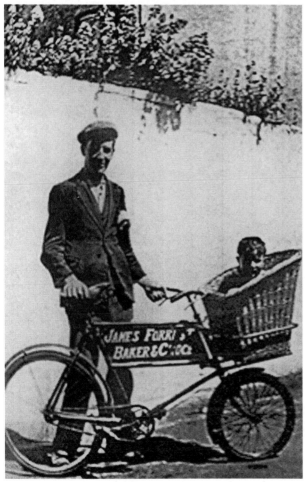

Mikey Roche, many of whose photographs appear in this book. He spent most of his working life as a projectionist in one of the cinemas in town. Born in 1920, Mikey worked first for the Hurst cinema, then for the Horgan cinema and finally for the Regal cinema. He took his camera everywhere – even when going for a haircut, as you will see later. There are many memories of Mikey Roche in Youghal going to and from the railway station with reels of film and publicity shots in his wheelbarrow. There are even stories about posters of film stars in scanty outfits having their 'indiscretions' painted over by Mikey, who was scandalised by such images. (Courtesy of the Mikey Roche collection)

A 'delivery boy' delivering a 'boy' – what else would a delivery boy deliver? Jim Coughlan is the little boy in the basket of Tommy Troy's bicycle. James Forrest's bakery was off Foxes Lane. (Courtesy of Mike Hackett)

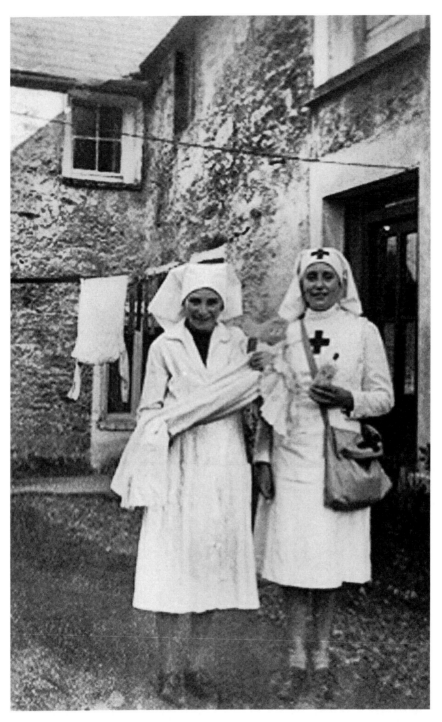

Two dashing young nurses from St Raphael's Hospital. (Courtesy of the Horgan family)

5

SHOPS

In the late nineteenth and early twentieth century the brothers Tom, Jim and Philip Horgan were well known in Youghal. They had a photographic studios and a shop in town. In 1892 they began to experiment with photography using the pinhole technique and later adapted a Lumière brothers projector to enable them to project the images they took. They then took photographs of events around Youghal and the surrounding villages. People were thrilled to see images of communions, weddings and special occasions.

The Horgans also had their own postcards and drawings, and occasionally mixed the two. Perhaps their most famous piece of trickery was when they skilfully blended an image of boatmen with an image of the Clock Gate, making Youghal look like Venice!

A visit to the Horgans' studio was a major event for local families, at a time when most people did not own a camera. The Horgans were serious professional photographers, with studio props, backdrops and cards, and customers could get formal photographs in a studio setting presented in an embossed card. These formal images became treasured possessions for people, particularly if they were of family members who subsequently emigrated.

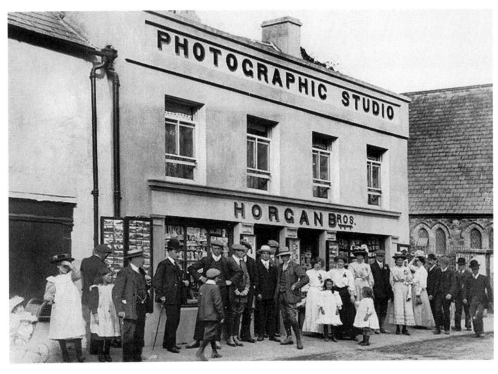

Horgans' Photographic Studio. (Courtesy of the Horgan family)

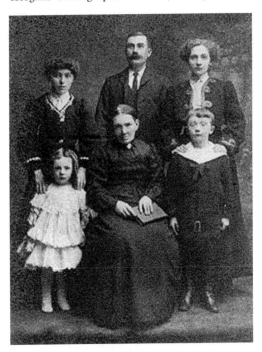

A family photograph as presented by
the Horgans. (Author's collection)

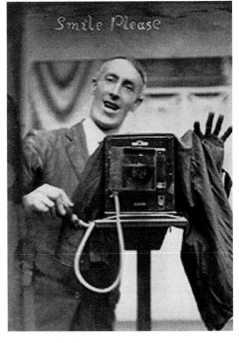

Jim Horgan waiting in his studio –
Smile please! (Courtesy of the Horgan family)

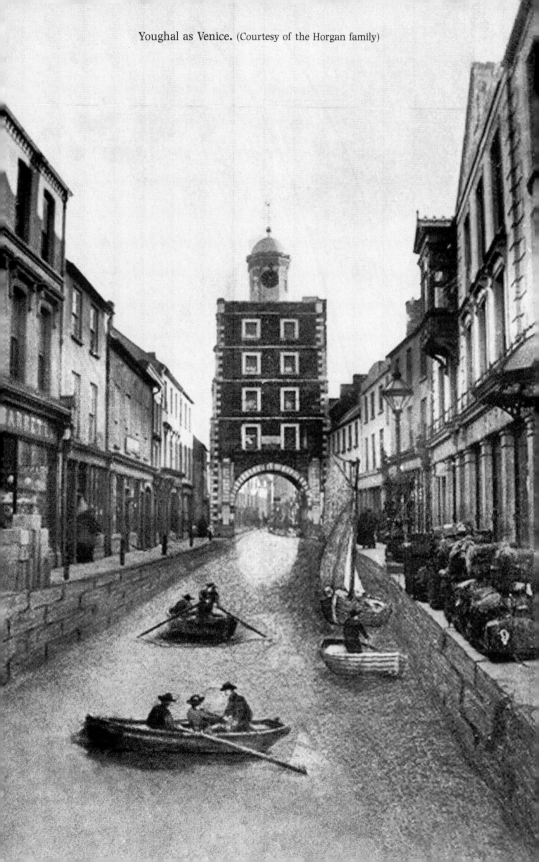

Youghal as Venice. (Courtesy of the Horgan family)

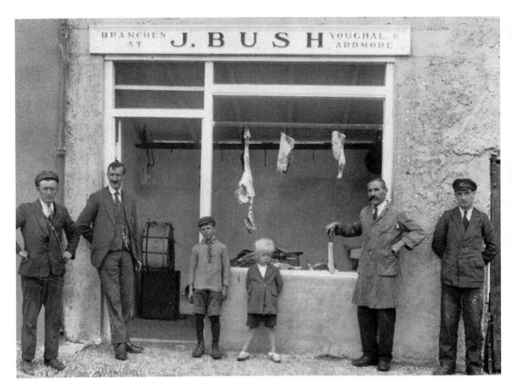

Jim Bush's butcher's shop. Pictured, from left to right: Mr O'Halloran (postman), Thomas Bush, two little boys, Jimmy Bush and Mr Morrisson (Esso driver). (Courtesy of the Horgan family)

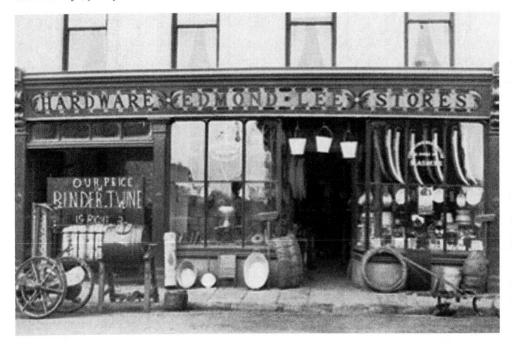

Lee's Hardware Store. (Courtesy of the Horgan family)

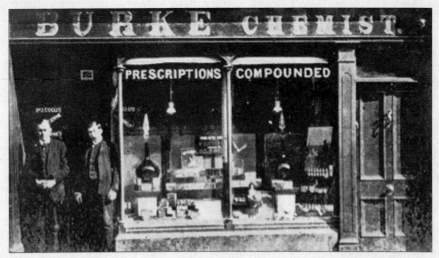

This is the chemist shop of William James Burke (pictured here with the moustache and an unnamed assistant). The shop was founded in 1898. His son, James, was a keen photographer and tested all new cameras he would be selling. Lesley Snell recalls buying his first camera, a Kodak Instamatic, from James Burke. James Burke took several photographs of the making of the *Moby Dick* film. (Courtesy of the Burke family)

Of the many shops along the Main Street, Merrick's shop was the largest. It was established, they claimed, in 1580. John Merrick was Mayor of Youghal in 1667. The most recent owner of Merrick's was Gordon Good.

The shop covered two floors. Merrick's also had a shop in Dungarvan. One photograph of a little wall showing the advertising gives us some impression of the grandeur there was associated with Merrick's. People travelled for 'miles and miles for the latest styles'.

Everything in Merrick's was neatly laid out in an elegant display. Probably what impressed many people was the money collection system. Nothing was collected at the counter. Money was placed in a little receptacle that was then, via a vacuum system, sent upstairs where a receipt was issued and change given. The little receptacle then shot down to the counter to the exact till spot where the money was paid.

Posters for Merrick's. (Courtesy of Brendan Hally)

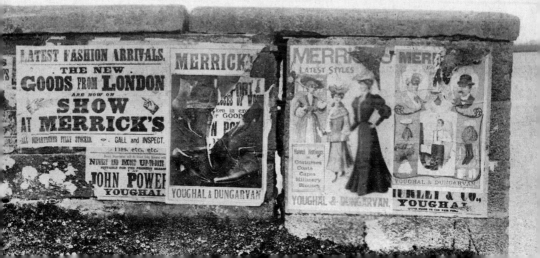

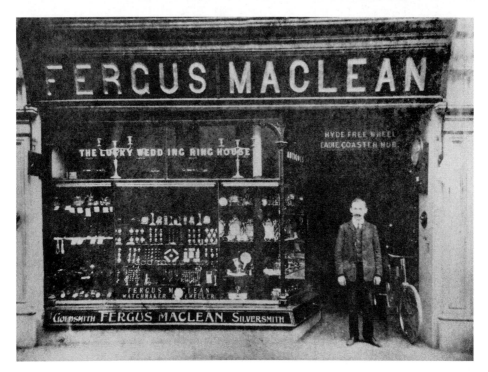

Fergus Maclean sold all sorts of things in his shop – from wedding rings to bicycles. His son Roy was not averse to putting on his bicycle clips, hopping on a bicycle, and heading off for a quick cycle when things were quiet. (Courtesy of Frank Keane)

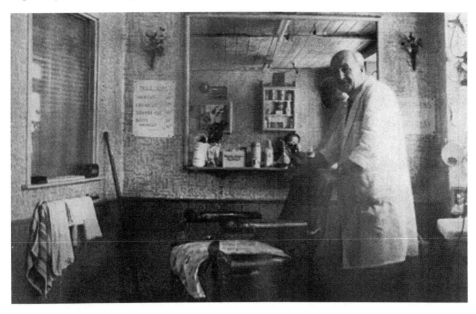

This was Jack Sullivan about to do his job as a barber, but first his customer, Mickey Roche, wants to take a photograph of him. Mickey, however, has forgotten the mirror and appears in his own photo. (Courtesy of the Mikey Roche collection)

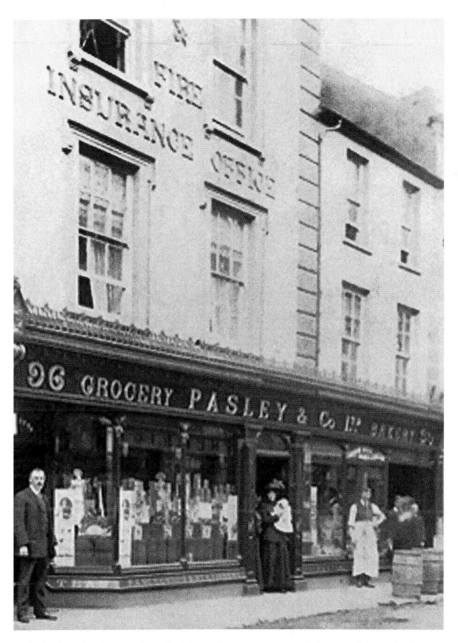

Pasley's shop has been in Youghal for well over a century. It is essentially a family-run shop with a loyal staff and even more loyal clientele. Upstairs there was an Insurance Agency run by the family. (Courtesy of Ken Brookes)

Pasley's in 1953. Look at the front left-hand corner and you see a sign for 'An Tostal' and a harp. An Tostal was a special festival set up by the government in 1953 to celebrate Irish life. It is mostly forgotten today except by the members of the local Bridge Club in Youghal who have run the Tostal Cup every year since then. You also see one of Billy Matthis' incredible matchstick creations – this one the beautiful Round Tower at Ardmore. (Courtesy of Ken Brookes)

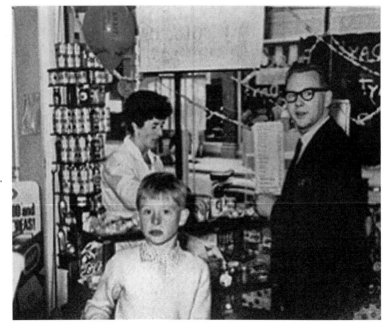

Probably one of the biggest changes facing family-run shops has been the change from counter service to self-service. It all sounds so simple today but this was a major development at the time. This is Gordon Good being served at the counter at Pasley's. (Courtesy of Ken Brookes)

'Pasley's Old Man' is a Christmas tradition. The little figure, staggering along rosy cheeked and with a bulbous nose, has been a great favourite in Pasley's at Christmas since 1880 and remains a huge attraction to this day. (Courtesy of Ken Brookes)

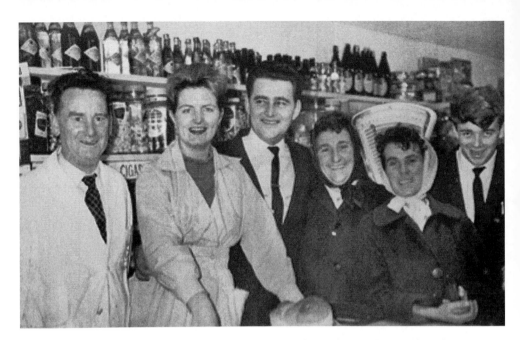

Happy staff members at Pasley's. From left to right: Paddy Doyle, Frankie Lynch and Larry Gogan (RTÉ Personality), two customers (one is Mrs Aher) and finally Pat White. Larry Gogan, a major radio personality with RTÉ, caused consternation when he visited Pasley's. The shop was swamped with customers on the day and everyone wanted to have a picture taken with him.

One of the wonderful features of Pasley's is the loyalty of staff and customers to each other. This is reflected in the length of time people spend as customers or staff in the shop and the recognition by management of this loyalty. (Photograph from Ken Brookes, courtesy of the Bob Bickerdike collection)

6

YOUGHAL
AT SCHOOL

There were several schools in Youghal in the past but eventually there were three at primary level and just one mainstream school at second level. The stories of the rivalry between the schools and the students who attended them are legendary. These rivalries were often quite pointed and involved a notion of superiority based on social class. Presentation girls were considered by Loreto girls to be 'working class' and therefore Loreto girls considered themselves 'socially superior' and apparently sang: 'Take off your hats you Presentation brats – And bow to the Loreto ladies.' The Presentation girls had a similar ditty to chant at the Loreto girls.

Eventually the bishop stepped in to stop the rivalry between Presentation and Loreto girls and decided that the Presentation nuns would look after the primary school girls and Loreto nuns would look after the second-level girls. There were several other changes and amalgamations since.

The Presentation Convent School taught girls how to make lace during the Great Famine and for many years after. Lace work was tough on the eyes and on the fingers, and took ages to complete. In 1911 the nuns were given a contract to make a lace train for a coronation dress for Queen Alexandra. It took 98,020 hours to complete – and even then there was consternation because they had inset into the lace '*deanta in Eireann*' (made in Ireland) – the train was refused until the offending words were removed. The nuns were given three months to make the lace train; it works out at about 100 hours a week for sixty workers. If there had been just one lacemaker it would have taken forty-nine years to do the job. Today the train is in the Victoria and Albert museum in London.

A lace wedding dress. (Courtesy of the Horgan family)

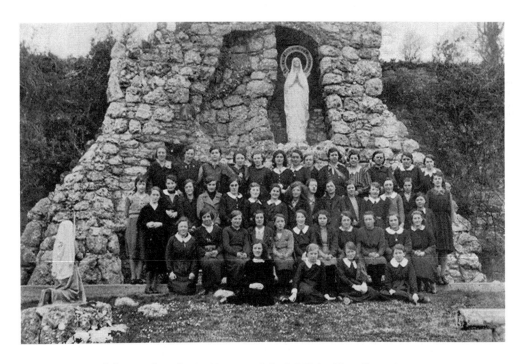

Sister Mary Magdalene and students. (Courtesy of the Bob Bickerdike collection)

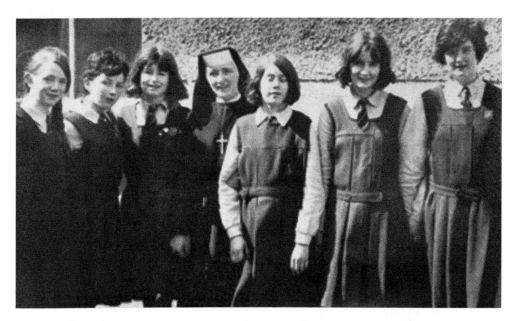

Girls from the Presentation Convent at the grotto. These Presentation girls are, from left to right: Ann Quain, Tisha O'Neill, Frances Doyle, Sr Mary Magdalene, Ann Walsh, Carmel Doolan, Paula Kelleher. (Courtesy of the Horgan family)

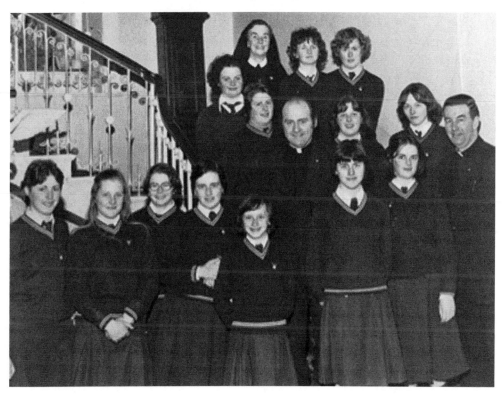

Loreto girls with Fr Kelleher and another (unnamed) priest. (Courtesy of Mike Hackett)

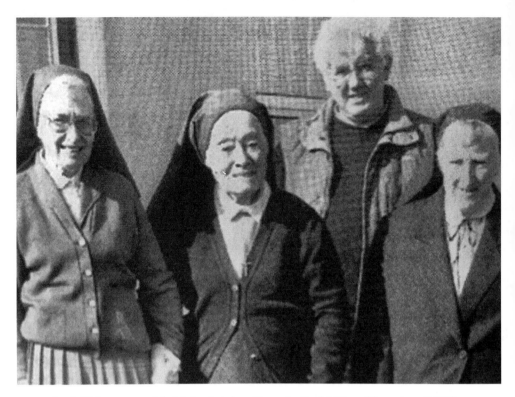

Sr Loyola, Sr Philomena and Sr Michael pictured here, in the 1990s, with past pupil William Trevor who attended the Loreto Primary School in Youghal. (Picture courtesy of *Memories of Loreto Youghal*, published 2003)

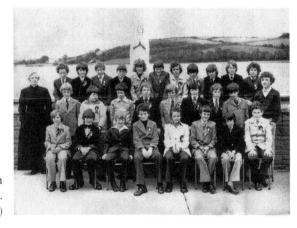

Confirmation class in the old Christian Brothers Primary School.
(Courtesy of Kevin Power)

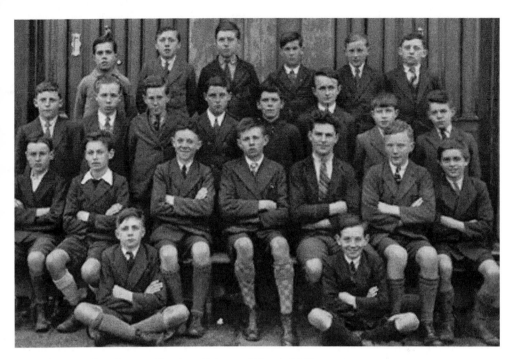

Pupils of the Christian Brothers Primary School, 1933. (Author's collection)

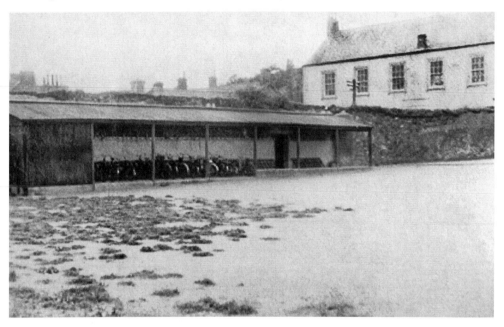

The old Christian Brothers School (CBS) yard was alongside the sea in Strand Street and there are many hair-raising stories of boys playing ball, the ball going over the wall and boys thinking nothing of jumping after it! The school building itself is now demolished. The brothers themselves would appear through the little black door at the end of the yard and escort the pupils to school. (Courtesy of Mikey Roche collection)

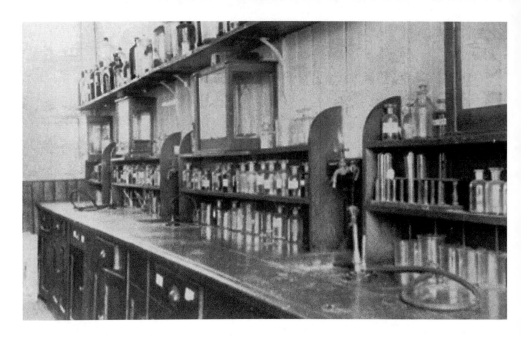

The science laboratory in the old CBS school. (Courtesy of the Mikey Roche collection)

The CBS class of 1942. (Courtesy of Kevin Power)

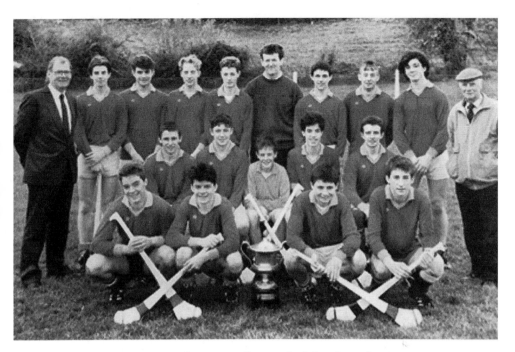

A Youghal CBS team, *c.* 1992. Teacher Liam Kelly is on the left with teacher Maurice Power in the centre. The gentleman on the right is Eddie Bulman. (Courtesy of Mike Hackett)

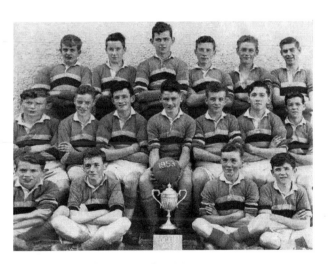

A CBS hurling team of 1924. (Author's collection)

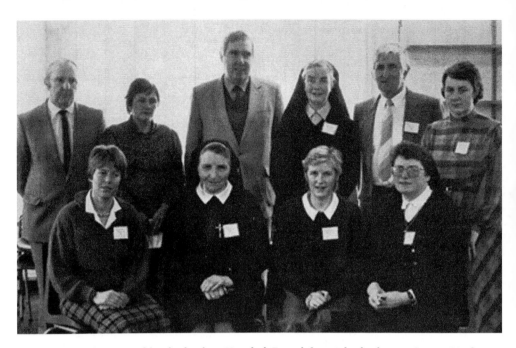

Meeting of the thee second-level schools in Youghal. From left to right, back row: George Ward (principal, Youghal Technical School), Maureen Hickey (CBS), Peter Nolan (Principal CBS), Sr Augustine, Con Buckley and Mary McAuliffe. Front row: Jill McKechnie, Sr Aquin, Patricia Dunlea and Sr Patricia. (Courtesy of Mike Hackett)

7

YOUGHAL
AT PLAY

Probably the single biggest sporting moment in the history of Youghal was when the Tour de France swept majestically through the town under the Clock Gate and up Lighthouse Hill in 1998. That was the year that Chris Boardman crashed on the outskirts of Youghal. It was also another cycling year marred by a drug scandal; but Youghal celebrated the tour and cheered and clapped and picked out the Irish cyclists like Sean Kelly and Stephen Roche who had worked so hard to bring the Tour to Ireland. Local photographer, Bob Rock, picked a wonderful vantage point on the cliff to capture not only the peloton but also the lighthouse in the once-in-a-lifetime shot shown on the next page.

Cycling was always popular in Youghal with criterium races being a regular event, cycling round the houses, up and down Windmill Hill, and out in Copperalley.

This chapter features a number of sporting moments in the life of Youghal – football, hurling, golf, badminton, camogie – and also takes a look at leisure – going to the cinema, the theatre and activities which are both leisure and theatrical, like Irish dancing.

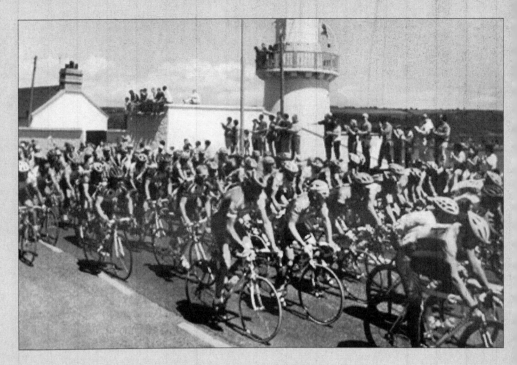

The Tour de France going through Youghal, 1998. (Photograph by Bob Rock, courtesy of Niall McCarthy)

A cycle race starting at Copperalley.
(Courtesy of the Bob Bickerdike collection)

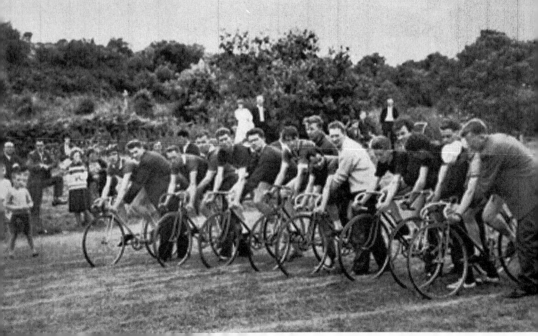

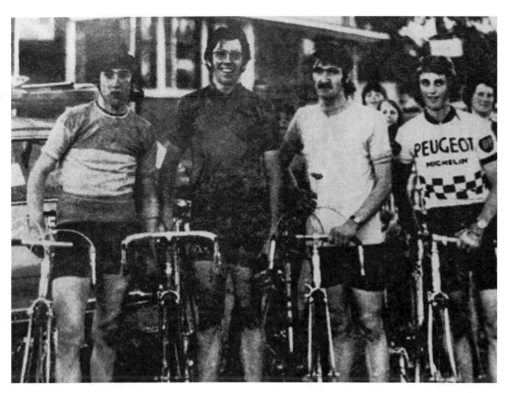

Sean Kelly, Oliver McQuaid, Gerry Geary and Kieran McQuaid (1974 winners). (Courtesy of Sean Lawlor)

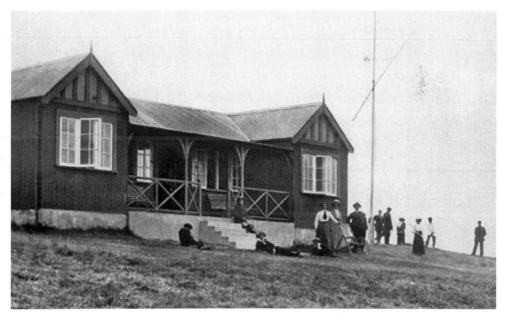

The old Youghal Golf Clubhouse. The size suggests something about the numbers of members. It is a links course with spectacular sea views. (Courtesy of the NLI, Lawrence Collection)

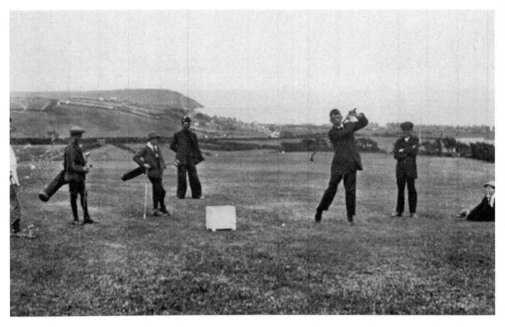

Some early, unidentified golfers. (Courtesy of the NLI, Lawrence Collection)

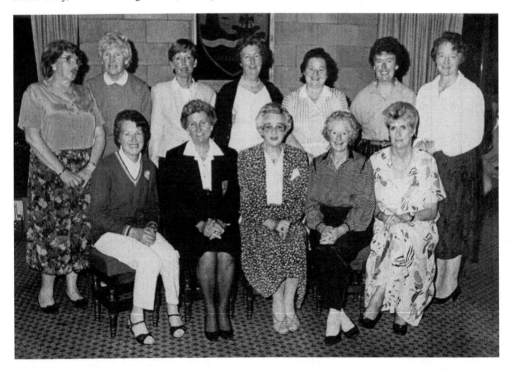

Lady Captain and former Lady Captains of Youghal Golf Club, from left to right, back row: Maura Power, Della Reid, Phil Byrne, Sheila O'Donnell, Kay Donnelly, Ann McCarthy and Terri Donovan. Front row: Mary Kennedy, Beryl Good, Mrs Riordan, Pearl Foy and Sheila Morrisson. (Courtesy of Frank Keane)

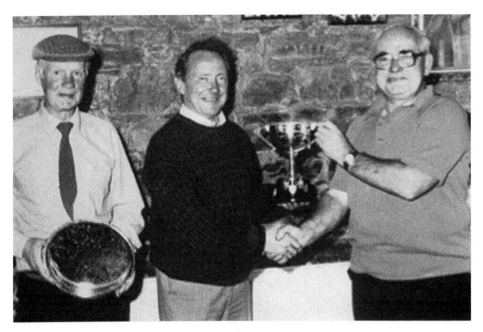

A billiards championship, *c.* 1962, featuring Eddie Bulman, Kevin Power and Christy Hennessy. (Courtesy of Kevin Power)

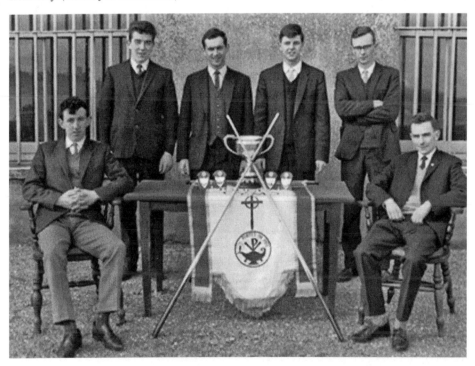

Winners of the billiards championship at the Catholic Young Men's Society. From left to right: Jack Donoghue, John Clerkin, Peter Cregan, Maurice Browne, Jimmy Horgan and Eddie Delaney. (Courtesy of the Horgan family)

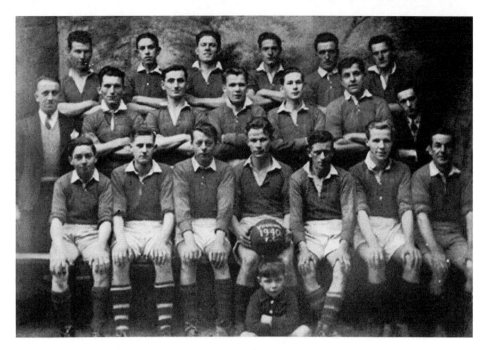

Youghal Football Team, 1940. (Courtesy of Kevin Power)

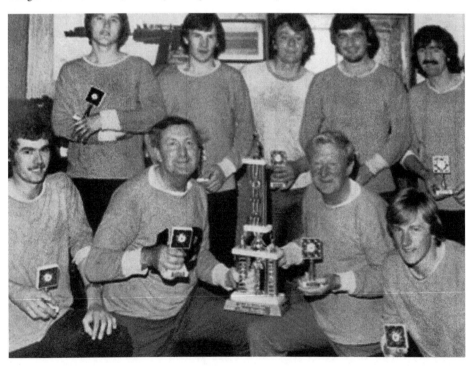

1978 Inter-Pub 7-a-side Gaelic Football Winners (Kevin Powers Pub). From left to right, back row: John Lougman, Don Mulcahy, Jim McCarthy, Paul Clerkin and Tony Hannon. Front row: Daithi Cooney, Jerry Kelly, Daithi Long and Eddie O'Sullivan. (Courtesy of the McCarthy family)

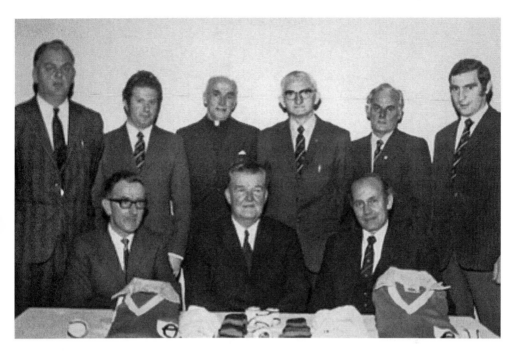

A presentation of jerseys to Youghal GAA Club. From left to right, back row: Liam Moynihan, Mick Hennessy, Fr Tom Paul Geary, Paddy Mulcahy, Paddy Cooney, Ned O'Connell. Front row: Gerry Murphy, Tom Cashman, Paddy Mulcahy. (Courtesy of Frank Keane)

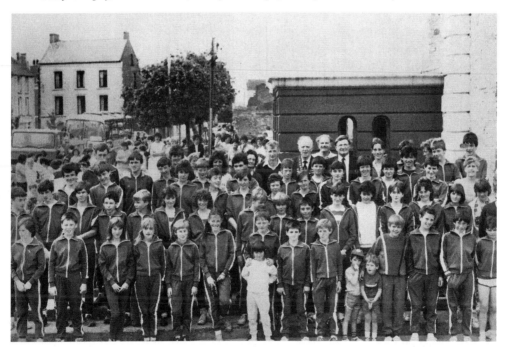

The Youghal Athletic Club being congratulated by officials at the Town Hall. (Courtesy of Mike Hackett)

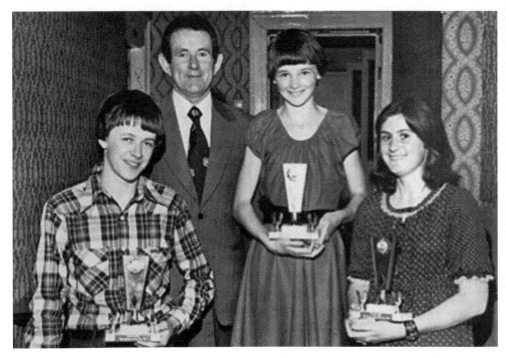

Recipients of awards from Youghal Athletics Club – Ger Flanagan, Ms Dempsey and Honora O'Mahony. The gentleman to the rear is Timmy Murphy. (Courtesy of Mike Hackett)

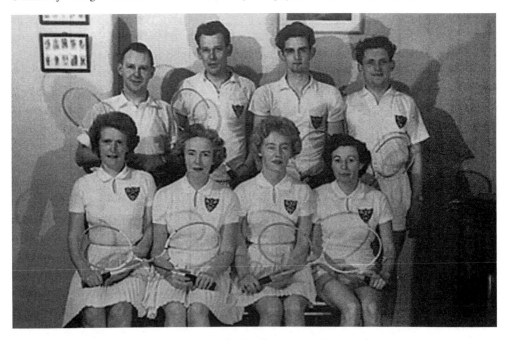

Youghal Badminton Club. From left to right, back row: Gordon Good, Eric Stanley, Liam Jennings and Eric Danne. Front row: Roma Peare, Carmel Brookes, Doris Binons and Hilda Clarke. (Courtesy of the Bob Bickerdike collection)

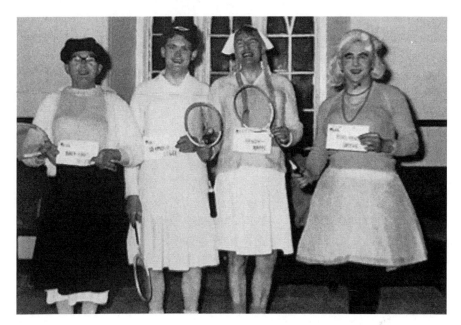

'Mixed doubles.' The winners in the Badminton Club in 1961 were the appropriately named 'Miss Backhand Shotte, Miss Seymour Legge, Miss Handycappe and Miss Forehand Dryve'. Rumour has it that the four young 'ladies' are in fact Eric Edwards, Eric Danne, Jack Brookes and Gordon Good. (Photograph from a private collection)

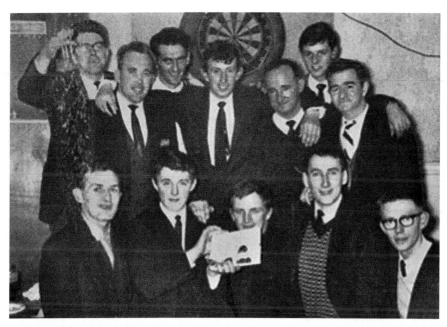

A group of dart players at the Green Park Hotel, 1962. From left to right, back row: Michael Paul O'Sullivan, James 'Moss' McCarthy, Peter Creedon, Jackie O'Donoghue, Paul Power, Maurice Browne, Kevin Kenneally. Front row: Frank Gowan, Willie Russell, Joe Ring, Gerry Stack, Tommy O'Keeffe. (Courtesy of Mickey Roche)

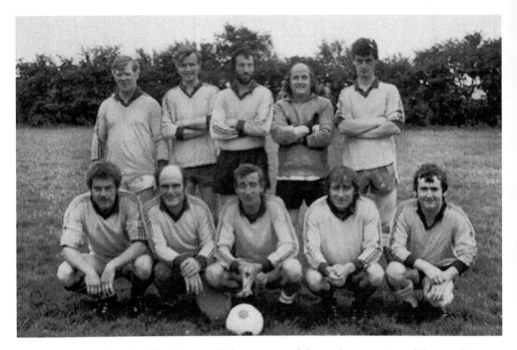

This is the Sarsfield Football Club, one of three soccer clubs at the time. From left to right, back row: Eddie O'Brien, Sean McCarthy, Willie Walsh, John Heaphy, Tommy Bulman. Front row: Jim Bryan, B. Daly, George Walsh, P. Heaphy, Patsy O'Regan. (Courtesy of Gerard Kenneally)

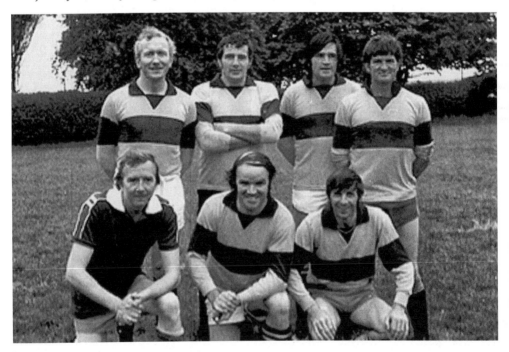

The Youghal 7s team. From left to right, back row: Paddy Lane, Pa Joe Terry, Stephen Mulcahy, William Joyce. Front row: John Terry, Mickey Downing, Donal Leahy. (Courtesy of John Heaphy)

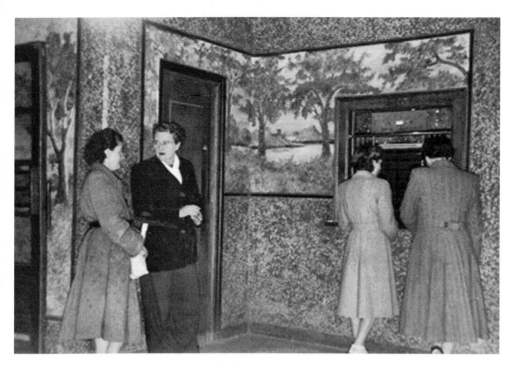

The Horgan cinema. The Horgan brothers built their own cinema – the walls beautifully painted by them with a variety of scenes. At one point there were three cinemas altogether in the town. A night out at the cinema was very popular. (Courtesy of the Horgan family)

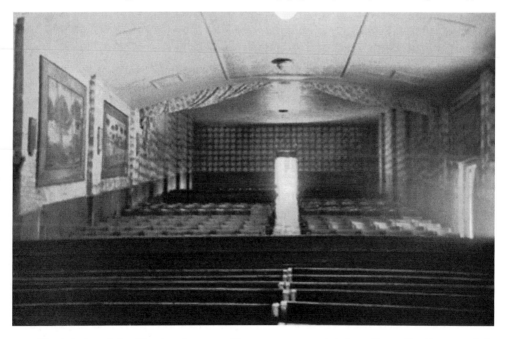

The interior of the Horgan cinema, with more scenes painted on the walls. (Courtesy of the Horgan family)

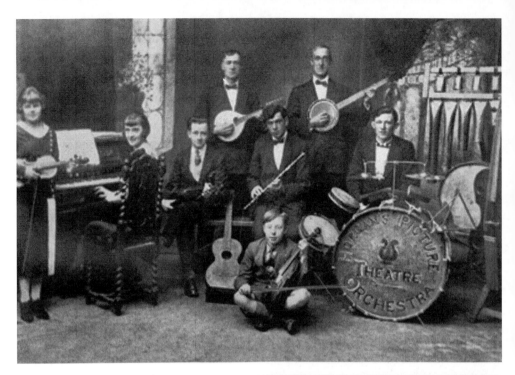

No cinema in those early silent-movie
days would survive without an orchestra,
so the Horgans had their own orchestra
and played in it, themselves, too.
(Courtesy of the Horgan family)

Mrs Keniry had an Irish Dancing School
for the young people of Youghal and
for generations she worked tirelessly at
preparing students for dancing competitions.
Pictured here is Cecelia O'Sullivan in
her outfit for Miss Keniry's school.
(Courtesy of the Bob Bickerdike collection)

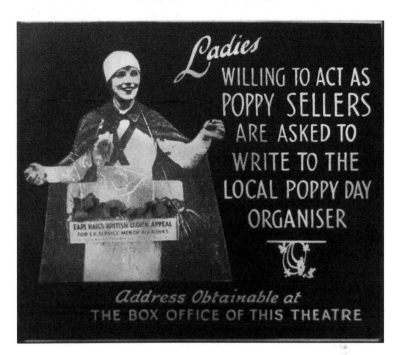

Just like today, advertisements were shown on the screen in the early days of cinemas. They were prepared on little glass slides.
(Courtesy of Mikey Roche and Horgan family)

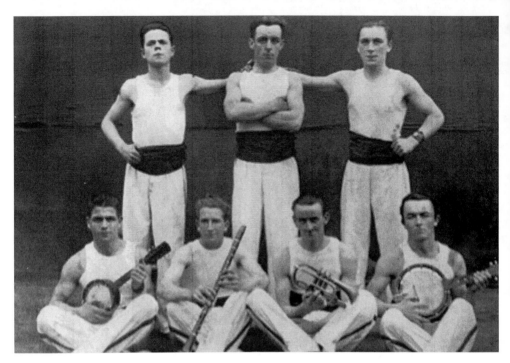

The Amingos' in the 1930s. The Amingos' (with an apostrophe!) were a popular local acrobatic troupe in the 1920s and '30s and performed their acts in several towns. Not many photographs of the troupe survive but Kay Donnelly has kept some memorabilia. Pictured, from left to right, back row: Bunny Roche, Jack Twomey and Paddy Coakley. Front row: Andrew Cronin, Danny 'Waddle' Sheehan, John O'Keeffe and Tommy 'Gotcha' O'Mahony. (Courtesy of Kay Donnelly)

THE AMINGOS'
Marvels of Acrobatic Ingenuity.

In the TOWN HALL,

on Tuesday, February 23rd, 1932

John O'Keeffe, presents

THE AMINGO ACROBATS'

Doors open 7-30 Commence 8-15.

ADMISSION 1/3

8

YOUGHAL
IN UNIFORM

Youghal has had an armed presence to guard it almost since the town first built walls to define and protect itself. Every now and then the garrison was rotated, with different regiments or different battalions of troops. Some prominent names served in the garrison, including the Duke of Wellington, Lord Edward Fitzgerald and James Connolly. In addition to the garrison there were also visiting troops who came to Youghal to stay at Claycastle for two or three weeks' rifle training.

But 'uniform' means much more than just the army, there were thousands of young men from Youghal who joined the navy, and there were thousands of young men and women who served in various occupations or musical groups which wore a uniform – the postal service, nursing, bus drivers, etc.

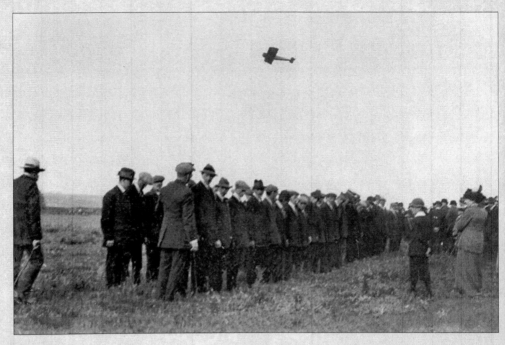

The year 1914 makes this photograph very interesting. Lord Carbery is performing a flyover and later a loop the loop to encourage young men to enlist. (Courtesy of the Horgan family)

The military band at Youghal Barracks.
(Courtesy of the Horgan family)

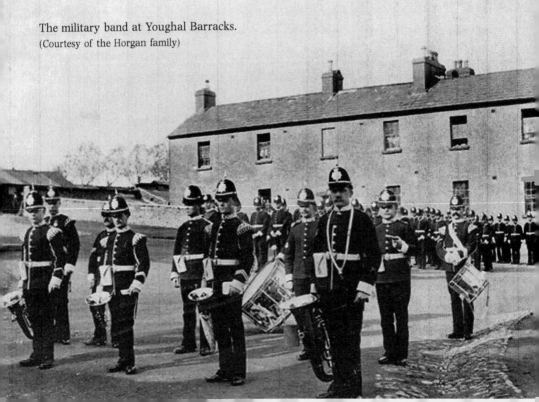

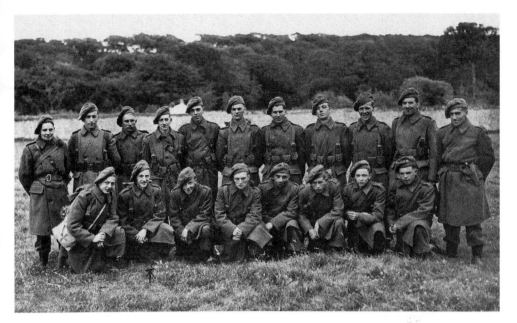

This is a group of LDF (Local Defence Forces) in training in Youghal, in 1943. The group includes Jack Kenneally in the centre of the front row. (Courtesy of the Kenneally family, photograph by Horgan family)

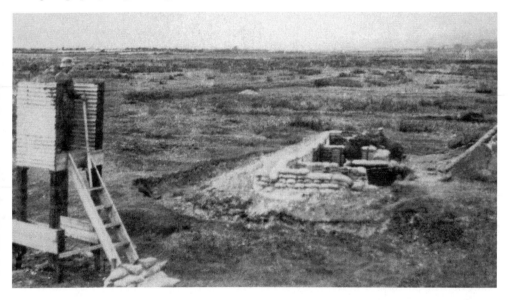

In addition to a garrison in the town, the army also camped at Claycastle for trifle practice and grenade training. Here is one such session. There are hair-raising stories of people collecting armfuls of 'duds' as souvenirs! About one third of all grenades were duds in the early days and spent cartridges were much sought-after by little boys (and some bigger boys). Of course, after that 'incident' in the Glen of Imaal, security was increased dramatically under Section 274 of the Defence Act, which gave soldiers great powers to prevent loss of life or limb by stopping little boys entering the range. (Courtesy of the Horgan family)

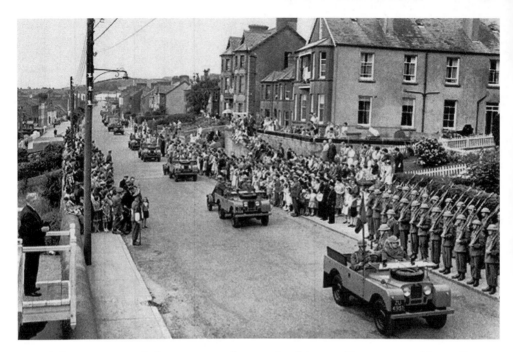

Part of the razzmatazz of the army was the parade of troops. The army would proudly display its strength at a march-past when the summer manoeuvres were over at Claycastle and Summerfield. This image comes from the mid-1950s, when a series of special manoeuvres were held in Youghal under the codename 'Blackwater'. There was a far greater army involvement that year, as the image shows, with the impressive parade into town when it was all over. (Courtesy of Gerard Kenneally)

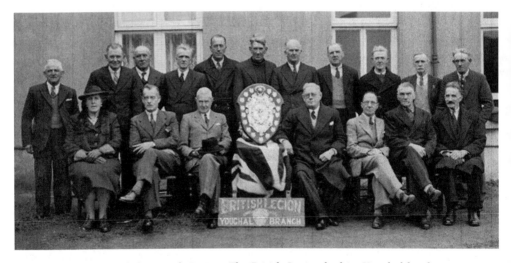

The Youghal branch of the British Legion. The British Legion had its Youghal headquarters near the Pier Head. They did a lot of fundraising to support those who had served in the British forces during the world wars. During the First World War over 1,000 men gave Youghal as their nearest town when enlisting and quite a number of Youghal people feature in the book *A Great Sacrifice*, published by the *Cork Evening Echo*. (Courtesy of the Horgan collection)

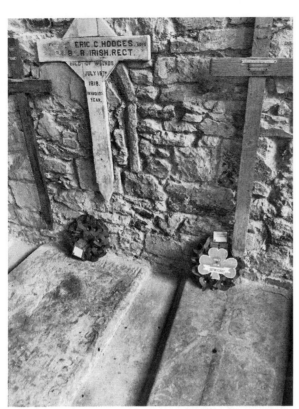

Three memorial crosses in St Mary's Collegiate church, remembering three young men who gave their life in the First World War.
(Author's collection)

The crew of the lifeboat *Lauranna Blunt*, including Maurice and Richie Hickey. The *Lauranna Blunt* served from 1931 until 1959.
(Courtesy of the Horgan family)

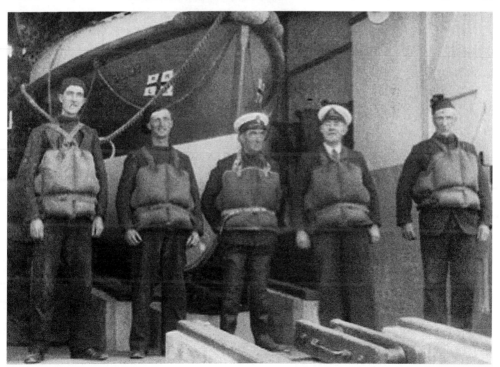

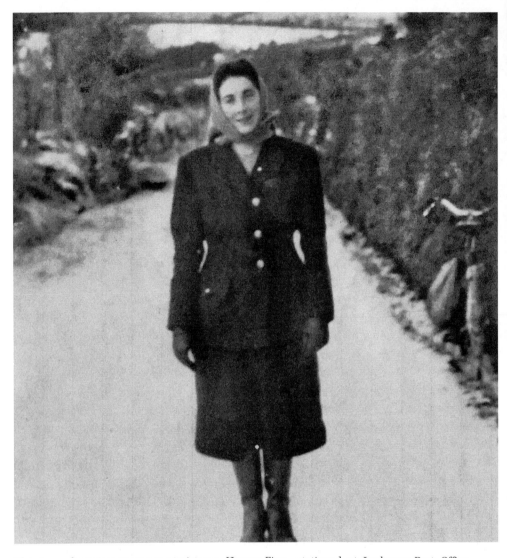

This is a charming young postmistress, Hanny Finn, stationed at Lackaroe Post Office, Youghal. She is out with her bicycle, defying the snow to deliver her letters. (Courtesy of Mike Hackett)

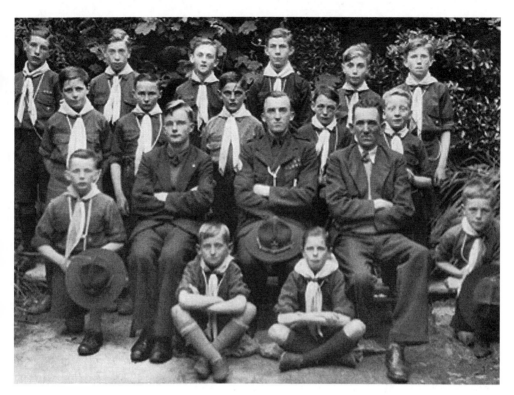

A Boy Scout troop. (Courtesy of the Horgan family)

The Blueshirts in Youghal in the 1930s. (Courtesy of the Horgan family)

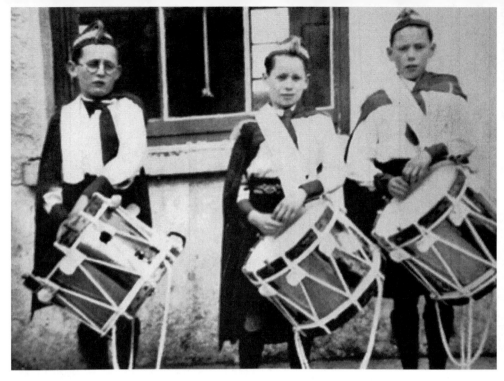

Three members of the CBS Pipe Band: Noel Hehir, Tom Delacour and Andrew Petersen. (Courtesy of Eddie Fitzgerald)

YOUGHAL PIPE BAND

Youghal Pipe Band celebrated their centenary in 2014, which is no mean feat. Every important occasion in Youghal – school, civic, family or ecclesiastical – has a piper to lead it out. It is part of the way the town does its business. This is due to a man called Danny 'Duis' McCarthy who, with a few friends, formed the band in 1914. A plaque in Barry's Square commemorates him.

A history of the band was compiled by Christy McCarthy in 2014. It features many of the places that were visited by the band, literally all over the world, and many of the occasions in which the band featured.

The band always operated with a military precision. Many of the bandsmen have served with distinction with the Irish armed forces and around the globe with the United Nations peacekeeping troops.

Danny Duis as a young IRA volunteer.
(Courtesy of Christy McCarthy)

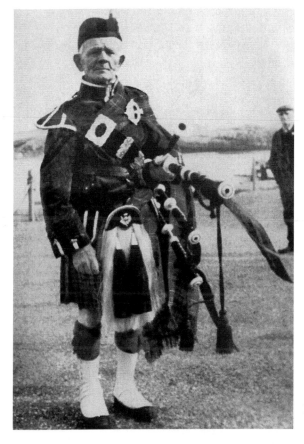

Danny Duis as a proud piper.
(Courtesy of Christy McCarthy)

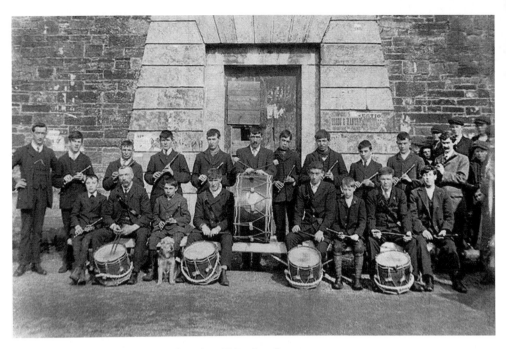

The Youghal Fife and Drum Band at the old Bridewell. (Courtesy of the Horgan family)

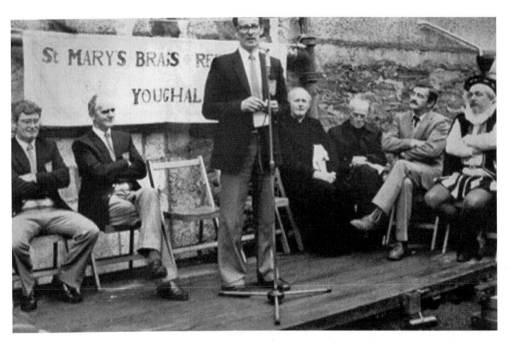

Tom Donnelly addressing a gathering of people waiting to hear the St Mary's Brass Band at Barry's Lane. The dashing young bearded man in tights to the right is Town Crier Clifford Winser and next to him is Cllr Denis Murphy. The occasion was the opening of the Band Hall. (Courtesy of Tom Donnelly)

9

THE FILMING OF
MOBY DICK

In the 1950s, journalist and writer Claud Cockburn (aka Jack Helvick), who lived in Youghal and was married to Patricia Arbuthnot of Myrtle Grove, convinced director John Huston that the ideal location for his next movie, *Moby Dick*, would be the little seaside town of Youghal because it had not changed much over the years and could easily pass for nineteenth-century New Bedford. Huston made a trip to Youghal, met local publican Paddy Linehan and so began probably the single biggest social event in the history of Youghal.

He signed a contract to lease the Town Hall and the centre of town became a huge film set. False fronts were put on houses, the harbour mouth was made to seem as if it was teeming with ships, hundreds of locals were dressed in period costume as extras, and many more provided for the needs of the film as set makers, sailors, costume makers, caterers, and taxis drivers. Mike Hackett (who has helped so much with this book) was one of the lucky children to feature as an extra.

Paddy Linehan's pub, now called the Moby Dick, was used as a set and has a wonderful array of memorabilia, including a fine mural of Youghal at the time, painted by Walter Verling. There are also a number of books about the movie. In particular, Mike Hackett's *Moby Dick at Youghal* in 1954 is well illustrated with some great stories, some of which are retold here.

A young chemist called James Burke took a series of photographs around the town and a tiny selection of these are shown here, courtesy of the Burke family. The Horgans were also there, along with many other professional photographers, looking for key moments (or maybe that should read 'quay moments').

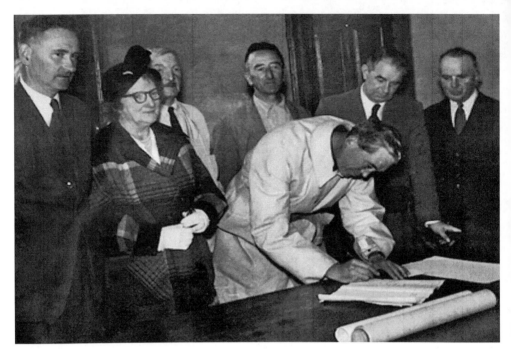

John Huston signing the contract. (Courtesy of the Horgan family)

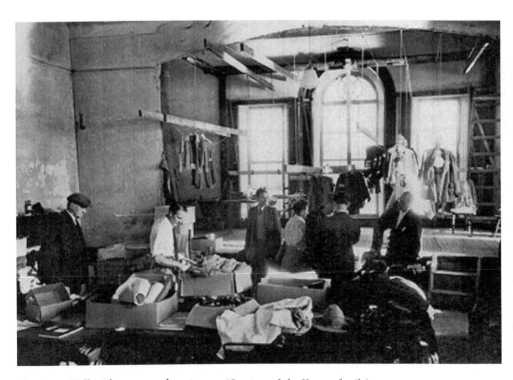

The Town Hall with props and costumes. (Courtesy of the Horgan family)

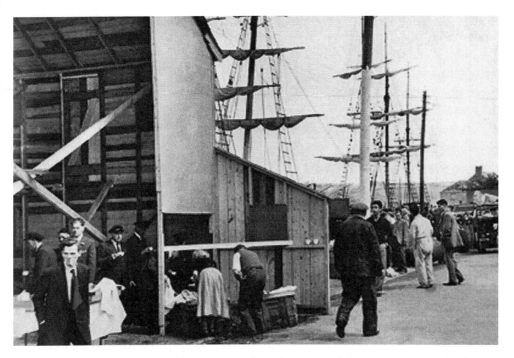

Michael Murray, a local builder, was invited to take charge of the construction of the filmsets. Here and there masts were 'planted' to make it look as it the harbour was full of boats. (Courtesy of the Horgan family)

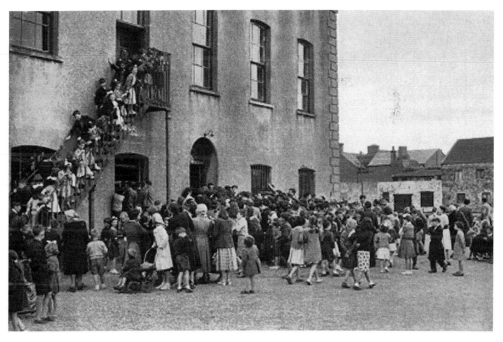

Townspeople queued in their hundreds to be assessed as possible extras in the film. There was good money to be had – 7s 6d a day. (Courtesy of the Horgan family)

This is Rosaleen Cronin, a well-known character in Youghal, and Noel Purcell. Rosaleen wanted Gregory Peck's autograph but the security people would not allow her direct access to the great star so she had a quick think. First she grabbed a telegram from the post boy and tried to brazen her way in. It didn't work. With a pair of scissors, she cut two holes in the bottom of a flour bag, then she pulled it up around her, tied the bits of string and suddenly ... she had a bathing costume! She dived into the water, swam around the dock and arrived at the Pier Head to demand an autograph from a very bemused Gregory Peck. She got it. Could he dare refuse such an enterprising woman? (Courtesy of the Horgan family)

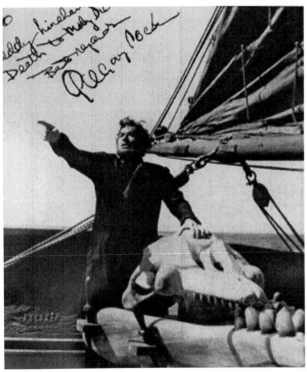

This is a card sent by Gregory Peck to Paddy Linehan thanking him for his assistance in the making of the film. It has pride of place in Paddy's pub, now renamed the Moby Dick, where one of the props made for the film can be seen – the ivory peg leg for Captain Ahab whom you see in the photograph.
(Card owned by the Linehan family, photograph by the author)

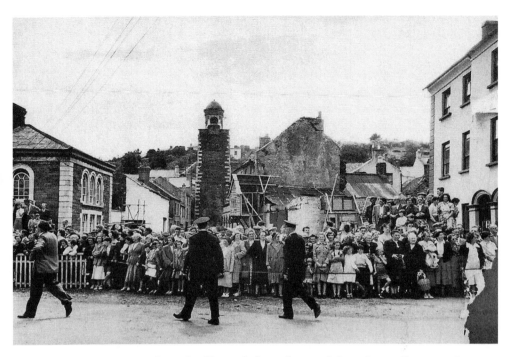

The excitement grew about the film and about the possibility of actually seeing the great stars. The Gardai put up crowd barriers to try and contain the situation. (Courtesy of Mike Hackett)

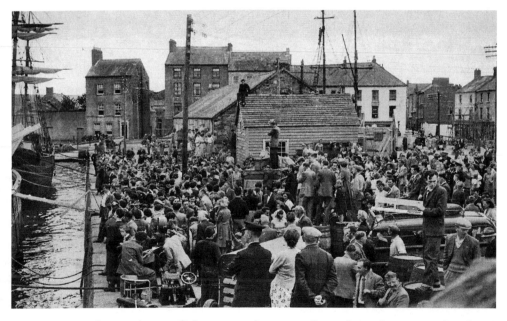

Sometimes the crowd just spilled over onto the quay wall; people stood on cars and on boxes, on benches just to catch a glimpse of whoever, whatever, they could. (Courtesy of the Horgan collection)

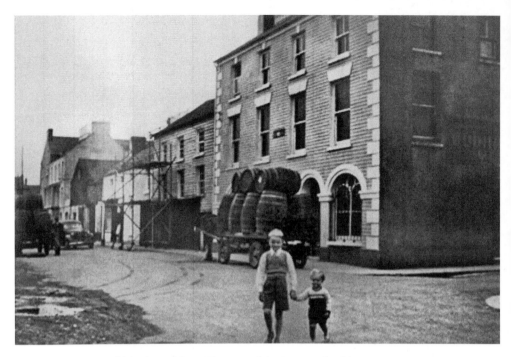

Christy Buttimer and his sister, Mary. (Courtesy of the Buttimer family)

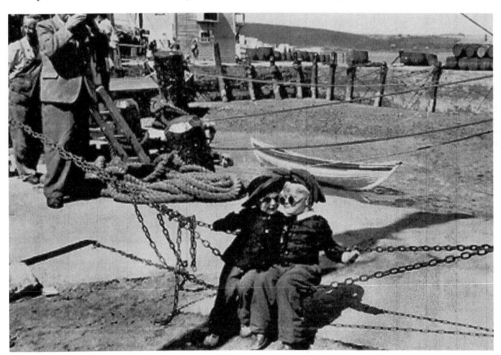

Two 'cool' kids, just hanging about! It is a little unusual to see such well-dressed children, with sailor hats and sunglasses in the Youghal of the 1950s. (Courtesy of Olly Casey, photographer unknown, possibly Gerry Ahern)

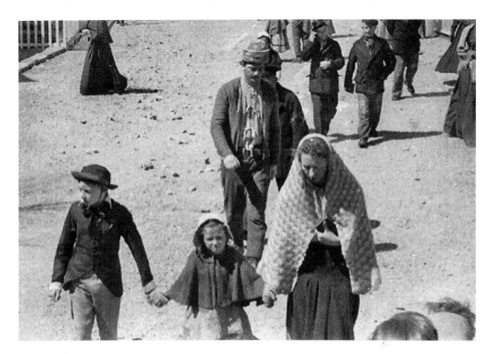

Mike Hackett in costume. (Courtesy of Mike Hackett)

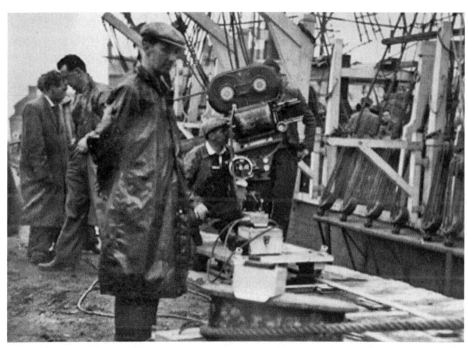

This is the scene at the quayside, by what is today Moby Dick's pub. It is almost show time. The *Pequod* is tied up and carpenters are working to make her look older. Locals employed as extras walked around, waiting for the moment when the camera would capture them on film. (Courtesy of the Roche family)

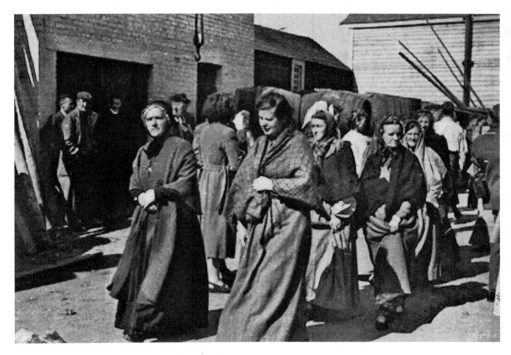

Some of the extras. (Courtesy of the Burke family)

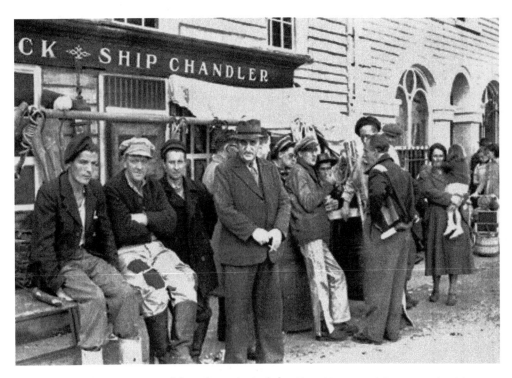

There is a lot of waiting around for a few minutes' shooting. (Courtesy of the Horgan family)

The large boat in the front is the town ferry, the *Angeline*, while the yacht in the bay belonged to Commander Arbuthnot of Myrtle Grove. (Courtesy of the Horgan family)

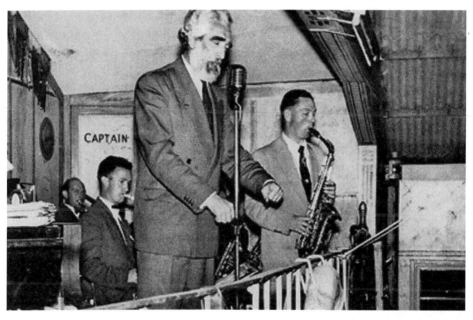

Noel Purcell, one of the Irish stars in *Moby Dick*, could be prevailed upon to sing a song or three. Here he is with Mick Delahunty's show band at the Showboat. That night was a special night – the filming had ended and practically everyone was there – except the goat, which had, more or less, become a mascot for the film crew. The goat was being kept in a garage in the Pacific Hotel just across the road from the Showboat. A local boy named Gussy Heaphy was asked to get the goat and, perhaps for the only time, a goat featured as a guest of honour in the Showboat! (Courtesy of Mike Hackett)

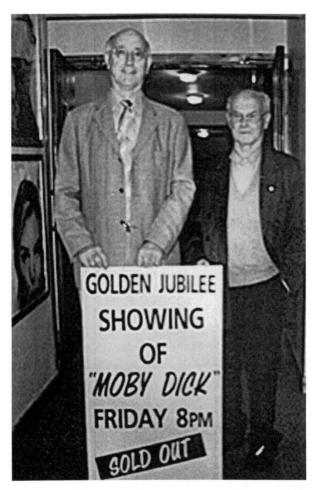

Pictured here are the proud owner (Harry Hurst) and projectionist (Mikey Roche) at the Golden Jubilee showing of the film. (Courtesy of Tommy Bulman)

10

SPECIAL OCCASIONS
AND MEMORIES

The next three photographs are astonishing – three moments in the Irish Civil War in August 1922. Anti-Treaty troops had taken control of Youghal and were aware that an attempt would be made to oust them. They blew up the quays to prevent a sea landing and mounted sentries at Moll Goggin's corner.

They did not take much notice, in the early morning, when what looked like a merchant ship headed into the bay. It was, in fact, the *Helga*, previously used in the 1916 Rising against the Irish. Under tarpaulins she carried over 200 soldiers, some heavy guns and lorries. She had a winch which enabled her to pull in near the Pier Head and offload her troops and equipment.

The Anti-Treaty troops fled, leaving their breakfast on the table in the RIC barracks.

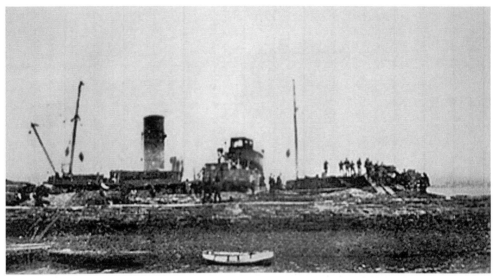

The *Helga* at the Pier Head.
(Courtesy of Mike O'Brien)

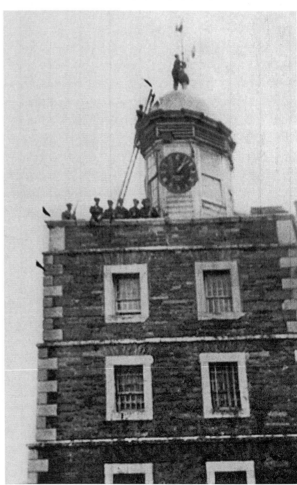

Mounting the flag of the Free State. One of the first things the Free State Army did was to climb the Clock Gate and mount the Free State flag. The photograph was taken by Roy Maclean, whose jewellery shop we have already seen. Also armed with his camera on the day was another shopkeeper – John Morrison Torrens – who photographed the troops in the street. At first glace, it all seems very casual; shops are open, carts are moving along. Look again, however, and you see a few shops are actually boarded up in anticipation of trouble. Torrens boarded up his own shop before heading off to photograph the event. (Picture by Roy McClean, courtesy of Mike Hackett)

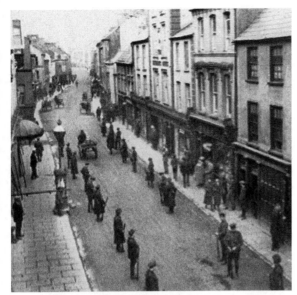

Free State troops line the streets. People are out walking, a farmer is delivering a churn of milk with his horse and cart, a few ladies are there. Some shops are open, but a few are boarded up. There was no resistance to the takeover and the soldiers do not seem very alert. It looks as if the owner of the shop nearest us on our right is starting to take down the security panels. (Courtesy of the Torrens family)

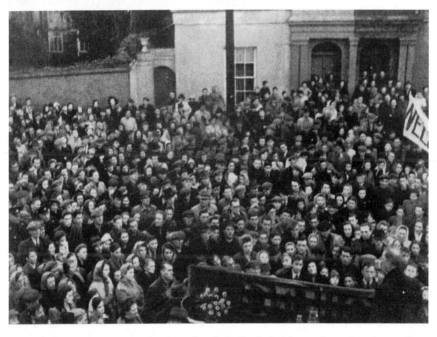

One of the most emotive elections for Catholic Ireland was brought about when a coalition government tried to introduce a health scheme which offered free medical care to all mothers and their children. It was called the 'Mother and Child Scheme'. It did not specify, however, that the mothers should be married! This caused enormous friction with Church authorities who believed it might encourage promiscuity. The Government fell and a difficult election followed. The 'future of Catholic Ireland' was at stake. Here Eamon De Valera is addressing a welcoming crowd at Youghal during an election rally in the early 1950s. (Photographer unknown, photograph courtesy of Diarmaid Keogh)

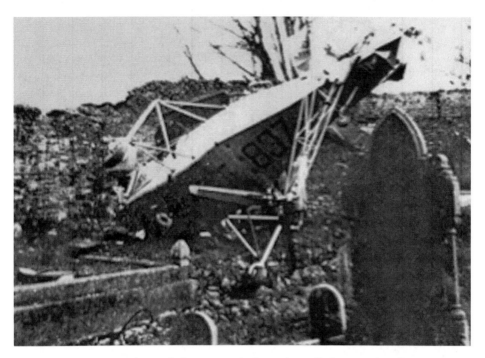

In February 1950 a Royal Navy helicopter crashed into the wall of St Mary's Collegiate church. It had been taking part in a coastal survey, developed mechanical problems and crashed. Again, Mikey Roche was on hand to capture the moment. (Courtesy of the Mikey Roche collection)

Every town has its characters, the ones who sit and comment on life and death and whatever takes their fancy. (Courtesy of the Horgan family)

Some just sit and watch as life flows by, a bemused twinkle in the eye. (Courtesy of Gerry Ahern)

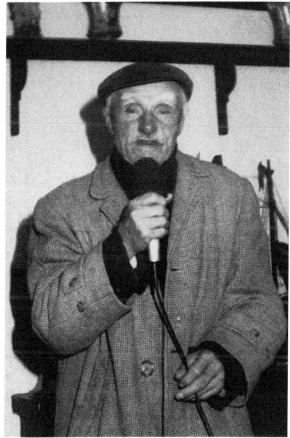

No Irish pub would be complete without the man ready, willing and able to give a 'few bars of a song' and Jimmy Delany was 'your man' in Youghal. (Courtesy of Tommy Bulman)

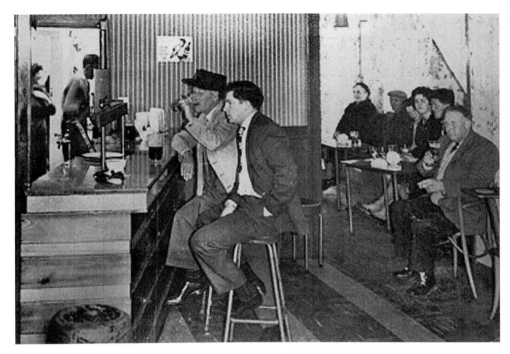

An Irish pub scene – this is the Moby Dick, and you realise how much things have changed when you see the cigarettes and the ashtrays. (Courtesy of the Bob Bickerdike collection)

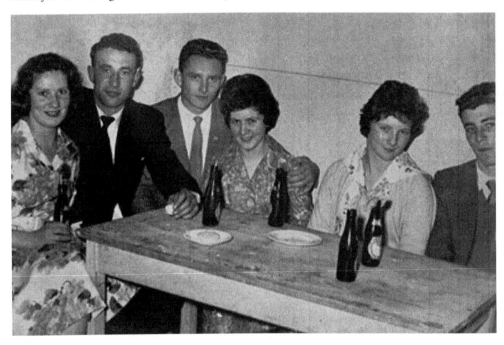

A night out with friends – all six with the little bottles of lemonade with straws sticking out of them, the table fairly bare with just a few arrowroot biscuits and not a cigarette to be seen anywhere! (Courtesy of the Bob Bickerdike collection)

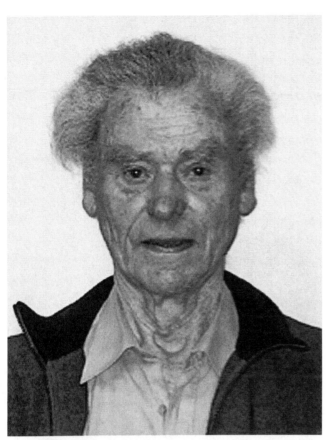

Bob Bickerdike. Bob has contributed so many images to this book it would be a pity not to include him! A political activist, keen photographer, elected member of Youghal Council, he led a full life and he has left us a lot of memories. (Courtesy of the Bob Bickerdike collection)

The Urban District Council in 1929. The council included Eddie Keane, Susan Harrington and Willy Broderick. (Photograph by the Horgan family, courtesy of Kevin Power)

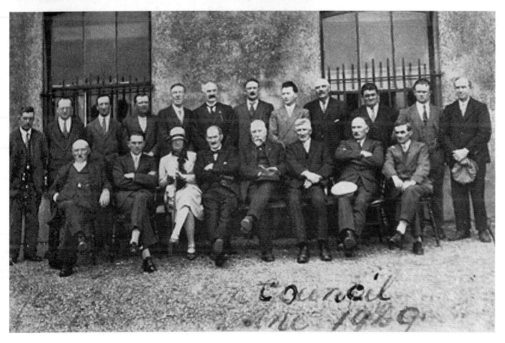

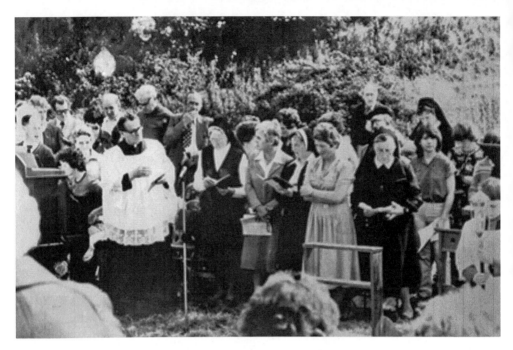

The blessing of St Coran's Well, Ballyclamasy, Youghal, by Fr O'Sullivan. (Courtesy of Tommy Bulman)

Members of Youghal Town Council examining proposals for a European Economic Community, later to become the European Community. From left to right: John Brosnan (TD), Tony Hickey, Paddy Ring, Seamas Walsh, Paddy Linehan, Gordon Good and Kevin Hennessy. (Courtesy of Mike Hackett)

The Lions Club, including Don Hennessy, David Keane, Bertie Lupton, Paul Murray, Noel Mackey, Morgan O'Connor, Michael T. Murphy and Michael Connor. (Courtesy of Mike Hackett)

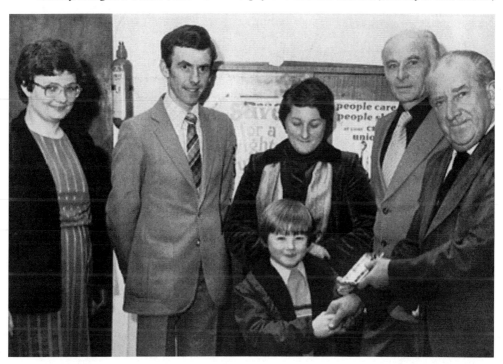

Youghal Credit Union on Ash Wednesday. From left to right: Eilis O'Connor, Frank Delaney, Mrs O'Sullivan, Brendan Ahern and Bill Cooper, and an unidentified young man who is as pleased as punch! (Courtesy of Mike Hackett)

PROCESSIONS

It is probably impossible to appreciate the importance of processions in twentieth-century Ireland, the extent of the involvement of the community, the numbers of people taking part. The Orange Order processions in the north of Ireland give a hint of the level of commitment and emotional ownership of the event.

There were many processions – St Patrick's Day, St Stephen's Day and so on – but the Corpus Christi Procession was really the big one. In Youghal literally everyone got involved. It was expected.

The Pipe Band, the Fife and Drum Band, the British Legion Band, the Brass Band, the Army Band, the Christian Brothers Band, St Mary's Brass and Reed Band, and lots of other bands would march past.

Pride of place went to the little boys and girls who had made their First Holy Communion that year. They would report to school dressed in white, each one with a threepenny bit, and for that would be given a sash. The little boys and girls marched separately.

The 'Children of Mary' would be next, a group of girls dressed in white veils with blue dresses. They would be followed by other school classes and then the various societies, sodalities and clubs. Next came occupational groups – teachers, nurses, the army and the fishermen. And if you weren't taking part you were on the footpath applauding, or being a marshal. It was a matter of intense pride to be part of the community, to share the values of the community and to display this by being there in one capacity or another.

Mikey Roche loved the processions and photographed many of them. The following is a small sample from the many processions through town. Sometimes the photographs do more than just record the groups who are marching. You can often see the names of shops that are being passed by – the L and N Tea Company, Sammy Adams Shoe Shop, Watson's Hardware. Occasionally the Horgans hand tinted a photograph, which gives it a very eerie effect.

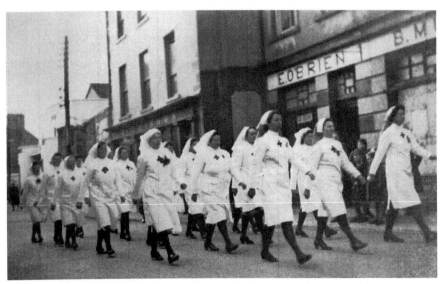

The nurses marching past in the parade with an almost military precision. (Courtesy of Mickey Roche)

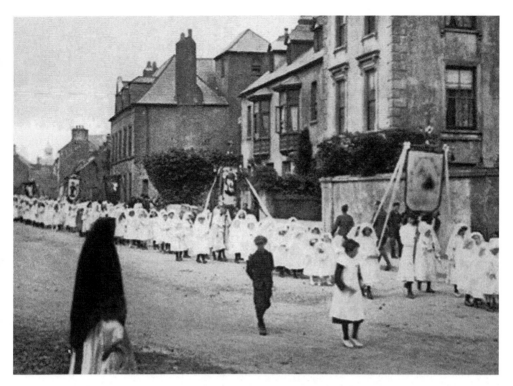

Communicants passing by Devonshire Arms. (Courtesy of the Horgan family)

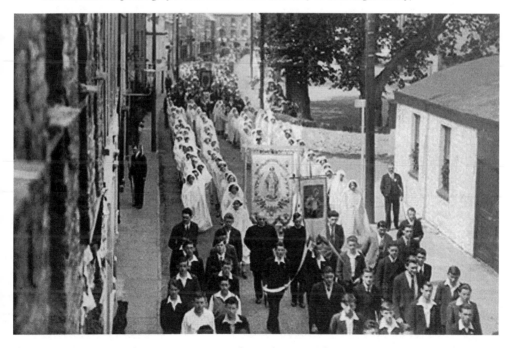

The communicants' procession now wending its way past the Town Hall. (Courtesy of the Horgan family)

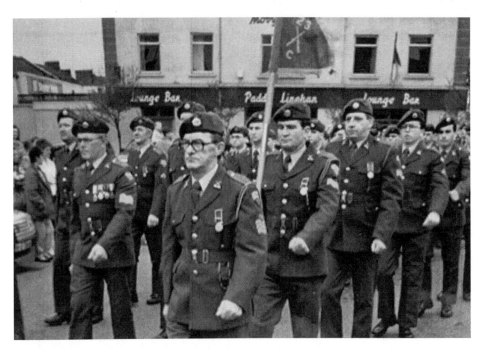

The army march past. The gentleman in the front right is Siddy Day. Behind him are Billy Joyce and Maurice O'Keefe and Liam Plante is on the left. Youghal and Midelton shared a battalion of the army so some of the men are from Youghal, some from Midelton. (Courtesy of Billy Matthis)

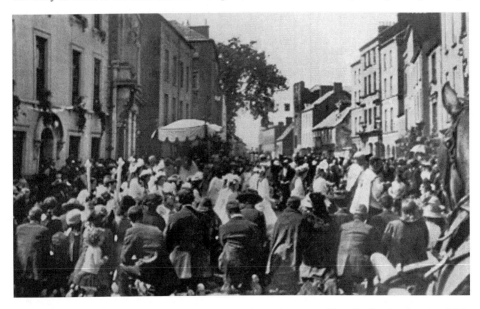

The Blessing of the Procession. Here you can just about see Tynte's Castle ahead, which gives some idea of the position of the photograph. The crowd is huge and kneeling down for a blessing. There were three major stopping points for processions – Green Park, the Pier Head and the centre of town. Houses would have bunting flags or papal flags flying. People proudly displayed their support. (Courtesy of Mickey Roche)

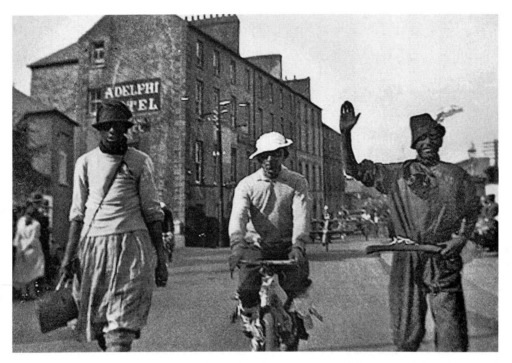

A final procession. It is not quite clear what this group were celebrating. The faces blackened and the strange costumes suggest an event like St Stephen's Day, during which men hunted the wren, 'the wren, the King of all birds, St Stephen's Day was caught in the furze'. It was a time-honoured Irish custom. There is a large crowd on the footpath applauding them. The little house on the corner near the Adelphi Hotel was owned by Nellie Maher, the lady who was selling boiling water to the day-trippers in chapter one. (Courtesy of the Horgan family)

Also from The History Press

IRISH DIASPORA

Printed in Great Britain
by Amazon